A

WES ANDERSON

DICTIONARY

A WES ANDERSON DICTIONARY

An A–Z of the iconic
director and his work,
from *Asteroid City*
to Steve Zissou

Sophie Monks Kaufman

ILLUSTRATIONS BY
NICK TAYLOR

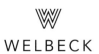

WELBECK

CONTENTS

INTRODUCTION

When an artist is as famous as Wes Anderson they
start to become caricatured in our popular cultural
imagination. We stop looking at the tiny details and
the hidden treasures within the work in favour of a
sweeping definition of who they are and where they
fit into their field. The purpose of this dictionary
is to examine the puzzle pieces of Wes Anderson's
cinema. I want you to enjoy each entry for each
entry's sake.

That said, an attempt has been made to create
entries that complement and enhance each other,
so that the reader will emerge with a satisfying
sense of this filmmaker. The dictionary can be read
chronologically or as you would a Choose Your Own
Adventure book. The "see also" section can assist
navigation in this method – although, warning: it
does not provide an exhaustive alternative route!

The building blocks here are his features,
although even the act of numbering these is
soluble. *The Wonderful Story of Henry Sugar* is 39
minutes, does that count? The closer you look at
Anderson's filmography, the further seemingly
definite facts drift.

One certainty is that Anderson the artist is
indistinguishable from Team Anderson. This
includes a loyal and expanding band of actors
from Jason Schwartzman to Tilda Swinton; his

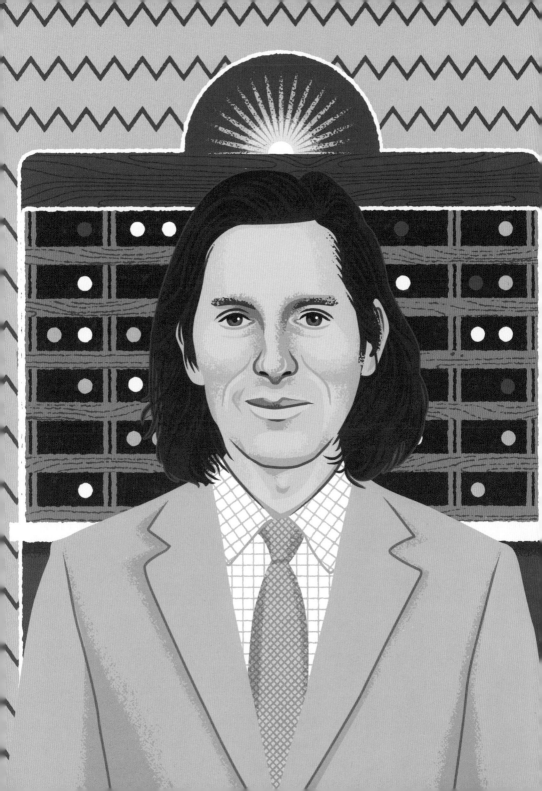

cinematographer from the first feature onwards, Robert Yeoman; legendary costume designer Milena Canonero, polymath producer Jeremy Dawson, expansive production designer Adam Stockhausen, and so on. One day, a book could – and should – be written about the creative family serving this one brilliant father. I have tried here to pay lip service to crucial and longstanding collaborators.

If it takes a village to deliver Wes Anderson's cinema to the world, then it has also taken the world to find these villagers. Wanderlust distinguishes both the man and his movies. From the filmmaker's location-scouting to characters boarding locomotives, everyone is on the move. As you travel through this dictionary, try to enjoy the sensation of forward motion. Even though, paradoxically, Anderson is full of nostalgia for lost worlds and cinematic influences that forged the imagination of a young boy in Houston, Texas.

There is a place in this dictionary for the cinematic techniques and design flourishes that make up Anderson's signature aesthetic. From whip-pans to Mendl's pastries, these are the binding ingredients and the cherry on the cake. While this is a celebratory little book, space has been afforded for a few choice criticisms, for to love someone is not to see them through rose-tinted glasses, it is to see them truly.

Make no mistake, this dictionary has been assembled with love and awe. It is my hope that as you flick through, dear reader, whatever storms are happening in your life and the wider world, the unique solace found in Wes Anderson's cinema will briefly blaze within one dainty detail.

Sophie Monks Kaufman

ACTORS

Not all directors respect the craft of acting. Alfred Hitchcock infamously said that actors need to be treated "like cattle". Nor do directors necessarily honour the psychological cost of performing. Movie lore is full of gruelling tales of the likes of David Fincher demanding take after take, while an actor is slowly losing the will to live.

Wes Anderson loves actors. The best way to open him up in an interview setting is to ask a question about a member of his troupe. He is endlessly interested in the surprising ways by which they bring his exactingly-written stories to life. Although there is pressure to deliver lines verbatim and at pace, Anderson does everything he can to create an environment that enables performers to do their best work. From having the cast and crew live together during the shoot, to making himself available to answer questions about a character, he shows his respect for the profession by creating the best possible conditions for the work.

On top of the quality of the end result, this is one of the reasons why he commands such loyalty. The likes of Bill Murray, Tilda Swinton, Willem Dafoe and Adrien Brody return to work with him again and again. New collaborators come aboard and report on the humble way that they were approached. "He's always uncertain as to whether

you want to work with him," said Jeffrey Wright in an interview with *Collider*. Wright joined the troupe to play a James Baldwin-esque writer in *The French Dispatch* and was invited back for the role of General Gibson in *Asteroid City*.

Anderson has entered the frame as a voice actor in two of his films: firstly, in *The Royal Tenenbaums* as the tennis-match commentator who relays Richie's on-court mental breakdown, and secondly in *Fantastic Mr. Fox* as Weasel.

ADLER, BEN

There is a special place in my heart for Ben Adler, a walking avatar for the "sky's the limit" creative confidence that Wes Anderson seems to instill in his collaborators. The English expat moved to Paris in 2006 to study film. In 2009 he responded to a Craigslist post stating that an international director was looking for an intern. This is how he ended up an assistant on *Fantastic Mr. Fox* and *The Grand Budapest Hotel*.

Like Jeremy Dawson, he was encouraged to grow and became an associate producer for *Isle of Dogs*, *The French Dispatch* and *Asteroid City*. One of his tasks is to make sure that hospitality is tip-top throughout each film shoot. Another is to oversee the prop exhibitions that have coincided with the release of these last three films.

On working with Anderson, Adler said, "He's always there to help guide things. And, if you have access to him to guide whatever you're doing, you should use that because the results will be stronger." We were talking at 180 The Strand during its *Asteroid City* exhibition and Adler was helping me with an article about why Wes Anderson's cinema offers solace to the neurodivergent community.

On neurodivergence he said, "The more that I learn, the more I see how relevant it is. I'm really passionate about having a bigger and bigger conversation about mental health publicly. And I think that's come a long way. But I know that, definitely as a Brit, growing up where there's such an ingrained British stiff upper lip that a lot of things don't get to come out and that can cause problems."

Afterwards, he went above and beyond to help me to talk to Jason Schwartzman and Wes Anderson on the subject. Nice one, Ben Adler.

ALIEN

"The way some people talk about him, you'd think the guy was an alien," Charles Bramesco wrote about Wes Anderson in his *Asteroid City* review for the *Decider*. Bramesco's point was that there is something autobiographical about the director's decision to put an alien in his eleventh feature film.

SEE ALSO:

Asteroid City

It's a clear night in the desert. Dr Hickenlooper (Tilda Swinton) has assembled all the junior stargazers, space cadets and their families to gaze at the night sky through a refracting box. As all tilt their heads to the heavens, a shocking sight appears; flashing green lights nearing until a spaceship appears, a ladder unfurls and an alien climbs all the way down. Its wide, round eyes give it a sweet and startled appearance. Indeed, the darting movements suggest a level of social anxiety as it plucks an asteroid from the ground, is papped by Augie and then leaves. The ladder, spaceship and green dots process reverses itself until the humans are by themselves again. Minus an asteroid.

There follows a military quarantine and intense conjecture about the alien and its motives. Fascinated kids make alien art, army men put witnesses through psychological testing and Augie and his jaded movie-star lover Midge (Scarlett Johansson) wonder if the alien thinks that they're doomed.

It takes an impromptu speech by singing cowboy Montana (Rupert Friend) to encourage everyone to take the alien in their stride: "I reckon that alien don't mean no harm at all. I reckon he just took hisself down here to have a look-see at the land and the peoples on it. In the spirit of exploration."

For all the soul- and solar-system searching it causes, the alien returns to drop off the asteroid

with an inventory number imprinted. The goal merely to itemize a lost item from its world.

ANGER

One of the major ways that Wes Anderson is often misunderstood is with the accusation that he makes neat and sanitized universes. While this is true of the aesthetic, the emotions that bubble up in his characters are as unruly as they come.

Even in the twenty-first century, anger is still perceived as "unfeminine", despite the litany of reasons for us to feel it. Twelve-year-old bookworm Suzy Bishop (Kara Hayward) knows her reasons in *Moonrise Kingdom*. She's angry with her mum for having an affair, with her dad for his despair and with her little brother Lionel for being a snitch. She's angry with her classmates for their lack of understanding and she's angry with herself...for being angry.

When she sees red, she lashes out. There is no restraint. Fury pops up like a cartoon POW. Other times it simmers at a low boil, apparent in glaring eyes and charged movements. She has a comrade in rage in Chas (Ben Stiller) from *The Royal Tenenbaums*. Stiller is an actor with a particular genius for embodying rage. His wiry frame seethes with ease, and he – like Hayward – finds the creative sweet spot whereby we both feel for the character's

SEE ALSO:

The Darjeeling Limited

Moonrise Kingdom

Neurodivergence

The Royal Tenenbaums

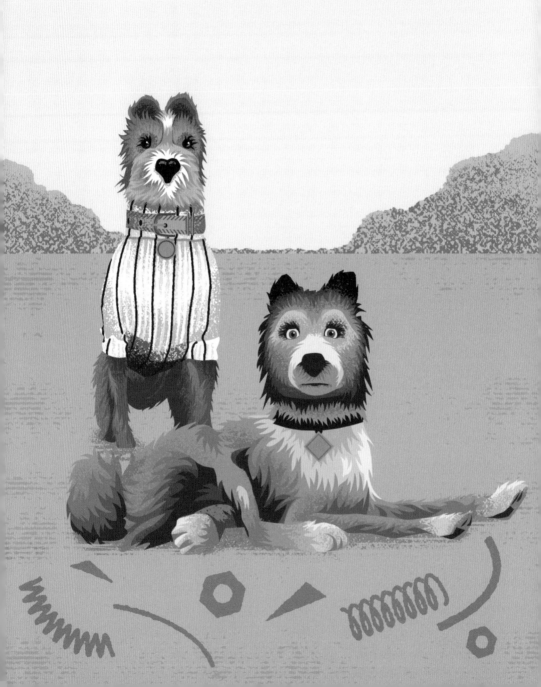

overwhelmed state and are amused by how it has taken them captive.

Anderson knows how to chart the trajectory that anger can take in a character. It can cool into despair or harden into meanness. Sometimes it turns into fisticuffs, as it does for the Whitman brothers in *The Darjeeling Limited*. Their fracas is filmed with a sense of its absurdity.

Characters are not penalized for their anger. Suzy and Chas end their films in a state of relative well-earned serenity.

ANIMALS

Well, of course, there are two animated films which directly centre animals who sound suspiciously like movie stars, specifically George Clooney (Mr. Fox in *Fantastic Mr. Fox*) and Bryan Cranston (Spots in *Isle of Dogs*). Humans are the villains of these yarns, seeking to subjugate and murder their creaturely co-inhabitants of this Earth. "Whatever happened to man's best friend?" Atari, the twelve-year-old ward of corrupt Mayor Kobayashi, asks. Cats are given short shift as the preferred pets of the mayor, malevolence gleaming in their eyes.

We could be forgiven for thinking that Wes has a bone to pick with cats, as one meets its end with shocking violence in *The Grand Budapest Hotel*. Legal eagle Deputy Kovacs (Jeff Goldblum) is the

SEE ALSO:

Fantastic Mr. Fox

The Grand Budapest Hotel

Isle of Dogs

The Royal Tenenbaums

proud owner of a fluffy white feline. Both are visited by a leather-clad group of heavies. On departure, assassin Jopling (Willem Dafoe) hurls the cat out of the window. A bird's-eye view confirms that this is now an ex-cat. White fur is splattered with red and its body is spreadeagled unnaturally.

To be fair to Wes, fictional dogs have also been harmed. Beloved family pooch, Buckley, is crushed by a car driven by high-as-a-kite Eli at the end of *The Royal Tenenbaums*. This film is a hotbed of unusual creatures: the dalmatian mice bred by Chas and Richie's pet hawk, Mordecai, who flies off when he is a child. Richie miserably nurses a crush on step-sister Margot for all of his adult life. At the end of the film Mordecai returns with more white feathers.

There is a good reason for this: the hawk who originally played Mordecai was kidnapped and held to ransom. Rather than pay up, the production team enlisted a second hawk actor, and its slight aesthetic difference was folded into the script. "I wonder what happened to him," Margot asks Richie, their secret love now in the open. "I don't know," Richie replies. "Sometimes if a person has a traumatic experience their hair turns white."

ANIMATICS

Up until *Fantastic Mr. Fox*, Anderson planned out the look of his live-action films using the standard

SEE ALSO:

Organization

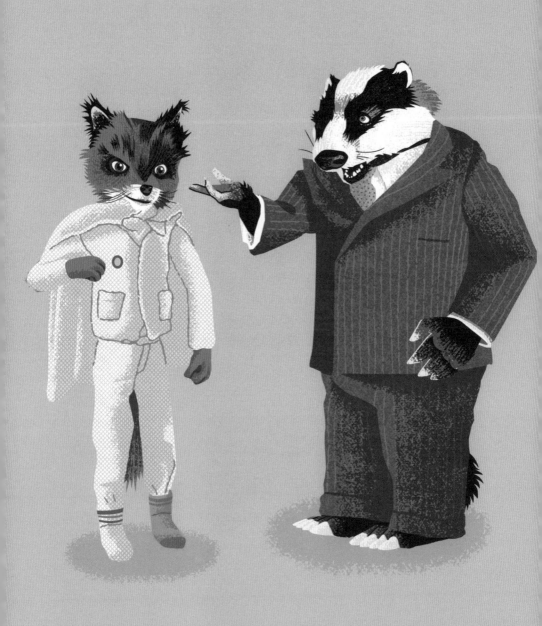

industry technique of storyboarding. Afterwards, he took an animation technique with him and began to create and circulate animatics in advance of production. These are animated storyboards with Anderson's voice reading out all of the characters' parts. On top of the look of the film and a sense of the camera angles required, they possess his intended rhythm, pacing and tone.

His collaborators frequently cite these animatics as invaluable in helping them to enter his elaborate sets with the knowledge of what is desired of them. The animatics are creative marvels in and of themselves and deserve, one day, to be projected in a cinema. Since *The Grand Budapest Hotel*, Anderson has used the talents of storyboard artist, Jay Clarke, to bring his animatics to life. The Criterion Collection released an extract of his work to promote the aforementioned title; it is well worth looking up on YouTube.

ARTIFICE

"I have the scar, still, I'll show it to you," says a character in *The Wonderful Story of Henry Sugar*, stepping out of his performance in one scene to address someone in a later timeline. In the original scene, his adversary has frozen in the act of smiting him. Blood drips down his leg from an impact that we have not witnessed, and yet we believe in it entirely.

SEE ALSO:

The Grand Budapest Hotel

Old Hollywood

The Wonderful Story of Henry Sugar

This type of blocking has more in common with theatre staging than filmmaking, with its emphasis on realism, and yet there is no reason why cinema audiences cannot suspend disbelief around theatrical touches. One of the most memorable examples of this was in Lars von Trier's *Dogville*, in which Nicole Kidman's Grace hides out in a "village" with separate houses demarcated by chalk outlines on an open soundstage.

Anderson has long owned that his films take place "five degrees removed from reality", and he is becoming bolder in owning and pushing the artificial elements of construction, perhaps as a way of showing those who criticize his lack of realism that this is fully intentional.

ASTEROID CITY (2023)

Grief is a motif across Wes Anderson's work. Death haunts *The Royal Tenenbaums*, *The Life Aquatic* and *The Darjeeling Limited*, and yet *Asteroid City* feels like the most naked excavation of this totalizing tax on our time on Earth.

It's 1955; Augie (Jason Schwartzman) is a war photographer (partially modelled on Stanley Kubrick) whose wife has just died of cancer. As he takes his four children to a tiny desert town named Asteroid City, so that his eldest, Woodrow, can compete in the Junior Stargazers Convention, he

has yet to tell any of them that their mother is dead. His confusion before an abyss of sorrow sets the tone for a film that is both formally dazzling and emotionally stark.

On the formal dazzlement: Augie's story is presented as a theatre play written by Conrad Earp (Edward Norton), meaning that, like all of the cast of *Asteroid City*, Schwartzman has two roles: Augie and the actor playing him (Jones Hall). The play is introduced by a "making of" TV broadcast. In total, there are three cultural forms in the mix. This is a story about storytellers and their tragicomic attempts to make sense of the insensible.

And how many storytellers there are. The joke about *Asteroid City* is that it's easier to list which movie-stars *aren't* in it. New recruits include Steve Carell, Maya Hawke, Tom Hanks and Hong Chau, while those drawn irresistibly back into the fold span Scarlett Johansson, Willem Dafoe, Tilda Swinton, Adrien Brody and Jeffrey Wright.

The set was built from scratch in the Spanish desert town of Chinchón. Anderson's inspirations, as ever, were rich and varied. From Westerns like *Bad Day at Black Rock* (1955), to the stories of Sam Shepard and the generation of American men who came back from World War II with PTSD, not knowing what it was. A mysterious intergalactic event makes *Asteroid City* eligible for the tag of "sci-fi", however, its machinations are all too human.

BALABAN, BOB

To the tune of "Barbara Ann" by The Beach Boys, Bill Murray led a rendition of "Bob-Bob-Bob Bob Balaban" at the Berlinale press conference for *Isle of Dogs*. This is the kind of affection that the diminutive and bespectacled journeyman of movies inspires.

Balaban's first screen role was a tiny part in the zeitgeist-defining *Midnight Cowboy* (1969), starring Jon Voight and Dustin Hoffman. In a way this is the perfect microcosm of his career. He brings his baleful charms to many brilliant projects, but usually is a little off to the side. "You really don't know who I am," he told *Vox* in 2018. "I'm an actor. I'm not famous. You've seen me in a hundred million things, and you have a vestigial memory of what I look like."

Balaban has been in five Anderson pictures: *Moonrise Kingdom*, *Isle of Dogs*, *The Grand Budapest Hotel*, *The French Dispatch* and *Asteroid City*. He is given most space in the first of these, as a narrator reporting on weather conditions from different parts of New Penzance.

Like Christopher Guest before him, Anderson knows how to play with the actor's distinctive energy. Balaban has worked with Robert Altman, Ken Russell, Steven Spielberg and Claudia Weill, but it is his collaborations with Guest and Anderson that sing from the rooftops. He is stunning in

Waiting for Guffman as the unpopular singing teacher who just can't get no release.

BAUMBACH, NOAH

SEE ALSO:

Fantastic Mr. Fox

The Life Aquatic

Noah Baumbach met Wes Anderson in 1998 at the NYC afterparty of *Pecker* by John "Pope of Trash" Waters. "We bonded because we both had the same little notebook in our pocket that we took notes in," Baumbach told Dustin Hoffman in a 2017 Q&A, "And we became friends."

They had a lot in common. Both were born in 1969, both were children of divorce, both were rising stars with two features under their belts. Baumbach: *Kicking and Screaming* and *Mr Jealousy*; Anderson: *Bottle Rocket* and *Rushmore*.

There was also a shared sensitivity. Waspish characters, tragicomedy, a preoccupation with disappointing dads and the manboys that they raise. The thematic and tonal overlap between *The Squid and The Whale* (2005) and *The Royal Tenenbaums* is striking. Dialogue from one could be inserted into the other without a rupture in internal logic.

Anderson was a producer on *The Squid and the Whale*. Just the year before, Baumbach co-wrote *The Life Aquatic*, with a blink-and-you'll-miss-it cameo as the floppy-haired lackey of a mogul played by Michael Gambon. In the screenplay the

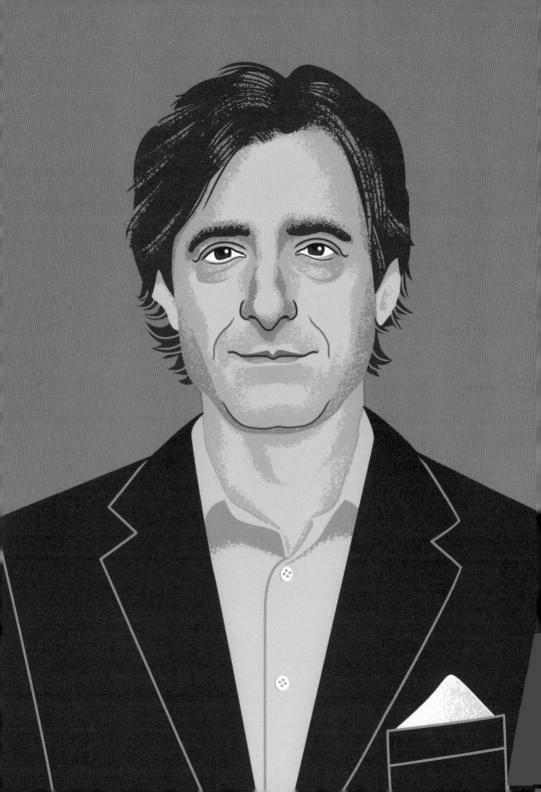

duo, dubbed "bards of broken homes" by writer Joshua Roebke went to town on their overlapping obsessions. Baumbach also co-wrote *Fantastic Mr. Fox*, and although this was their last collaboration, the ongoing creative importance of their friendship is clear. Anderson thanks him in the credits for *Isle of Dogs*, *The French Dispatch* and *Asteroid City*.

As their careers have evolved, they have stylistically grown apart. Anderson's aesthetic has become increasingly confected, with framing devices chopping the narrative, while Baumbach has kept to aesthetic realism and doubled down on the theme of acerbic New Yorker comedy dramas. An exception is his 2022 Venice opener, *White Noise*, a maximalist sci-fi with a tremendous set piece.

Look beneath their surfaces and certain commonalities remain. Both locate wrenching emotions by playing with contrast. The rug-pull that opens *Marriage Story*, whereby a loving couple are revealed to be divorcing, is not so different from the conversation that Augie has with his wife at the end of *Asteroid City*. Fantasy is so bittersweet.

BEACH DANCING

One of the most iconic moments in Wes Anderson's entire filmography is the beach scene in *Moonrise Kingdom* in which twelve-year-old runaways Sam and Suzy dance together in their underwear.

Suzy – when told to pack essentials – included a record player and a vinyl of "Le Temps De L'Amour" by French chanteuse Françoise Hardy. The song's nonchalant sexiness speaks to a world beyond adolescence and, although Sam and Suzy are nothing if not precocious, they seem their age as they stiffly shake their bodies to the music. These faltering movements, however, hold the freedom that they have both been seeking.

Sam – an orphan and an oddball with a flair for scouting – has been squirming for a chance to take charge. Suzy – a furious loner and lover of fantasy stories – has been going crazy for a chance to express her softer side. After they have grown used to the music, he approaches her to slow dance and they kiss. Then he spits to the side. He got sand in his mouth. Young love!

Child actors Jared Gilman and Kara Hayward achieved instant arthouse fame after *Moonrise Kingdom* premiered at the Cannes Film Festival in 2012 and went on to be Anderson's highest-grossing film in North America. Their beach scene was shot after rehearsals on a closed set, and was the very last one to be filmed.

BINOCULARS

A character raising binoculars to their eyes and/or the camera replicating binocular vision has been a

SEE ALSO:

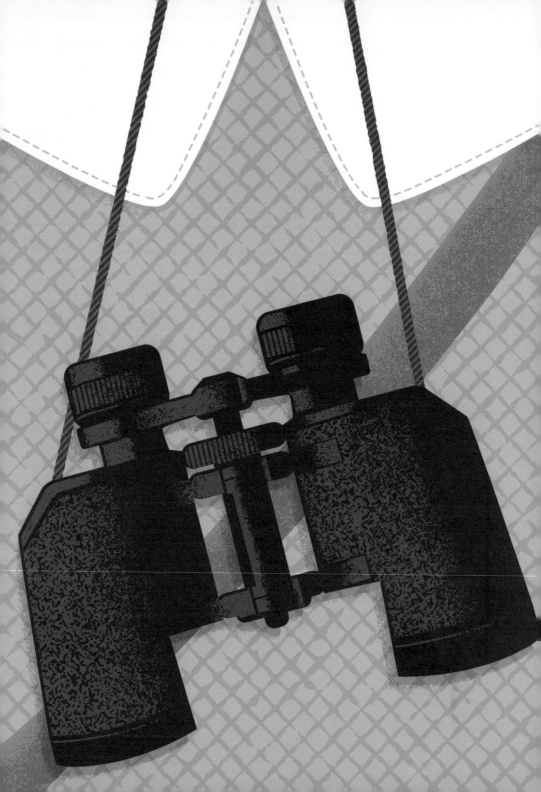

trope from the very first sequence of Anderson's very first film. Dignan brings a pair to surveille Anthony, ahead of breaking him out of a voluntary psychiatric ward in *Bottle Rocket*. Suzy Bishop in *Moonrise Kingdom* is so reliant on her pair that they hang around her neck on a cord. She uses them to spy on her mother's affair with "that sad policeman" (Bruce Willis).

After she runs away with Sam, with a suitcase packed with fantasy books, she confides in him that the binoculars are the source of her own magic powers. They help her see things more closely, even if they're not far away. A tool that helps us to frame life in greater detail, heightening our powers of observation, is not a million miles away from a movie camera.

BOTTLE ROCKET (1996)

Anderson's first feature makes for a fascinating watch. His most visually loose film contains the DNA of all that he is today. A short version of *Bottle Rocket*, played at the 1993 Sundance Film Festival, drawing the attention of producer James L. Brooks who laid on the funds for a feature adaptation. The resulting crime comedy caper holds up as a curiosity, despite being a commercial flop on release.

The Wilson brothers, Owen and Luke, carry the film with their languid Southern sensitivity.

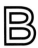

They play friends Dignan and Anthony, who, after breaking Anthony out of a voluntary psychiatric unit, pursue several small-time heists. Anderson's signature deadpan comedy is in full bloom, as is his tendency to arm characters with ambitious schemes and ruses. (Dignan has a 75 Year Plan.) There is even a classic needle drop. Anthony falls in love with Inez, a non-English speaking chambermaid at a motel where they are hiding out. To Love's "Alone Again Or", the two consummate their incommunicable feelings.

Anderson regularly remembers to stay humble by telling the story of *Bottle Rocket*'s initial test screening. People started leaving, he told his friend and fellow filmmaker, Noah Baumbach, at a New York Public Library event. At first, he thought that they were just going to the bathroom, but they didn't come back, and, anyway, who takes their hats and coats to the bathroom?

Despite its lack of box office success, *Bottle Rocket* was one of Martin Scorsese's favourite films of the 1990s. Not a bad outcome for a calling card.

BRODY, ADRIEN

Adrien Brody's greatest claim to fame landed early. At 29, he became the youngest ever winner of the Best Actor Academy Award for his performance in Roman Polanski's *The Pianist* (2002). If his

career has never quite lived up to this prestigious dawn, he remains a dashing and distinctive screen presence.

Brody is an in-demand actor, whose brief stint in the Emmy-blitzed HBO show *Succession* caused fan excitement, however, his work with Wes Anderson is a source of the most surprising delights. Unlike Bill Murray, who always plays variations on a theme of melancholy, Brody tends to plumb new depths for each new collaboration.

The slick but conscientious Peter Whitman in *The Darjeeling Limited* is nothing like murder-happy Dmitri Desgoffe-und-Taxis in *The Grand Budapest Hotel*. Determined art dealer Julian Cadazio in *The French Dispatch* is cut from a different cloth to virile, agonized theatre director Schubert Green in *Asteroid City*.

Brody is the Swiss-army knife of actors, with a tool to suit every circumstance. If there is a connection between each performance it is in his physicality. At 6-foot 1-inch he carries himself with great self-possession. Whether he is walking with relishful menace down a hallway in pursuit of Saoirse Ronan, or boxing out his nerves ahead of showtime, there is never a jot of clumsiness. Adrien Brody is large and in charge.

CAMEOS

It is not in Anderson's nature to leave to chance a detail that could be intentionally addressed and therefore add an extra little *je ne sais quoi*. So it goes for the fleeting characters. Whether these roles are filled by famous actors or unknown extras, his work embodies these words by Soviet theatre practitioner, Konstantin Stanislavski: "there are no small parts, only small actors."

In the early days, when Anderson and the Wilson brothers were kicking around Dallas, being spotted and doing spotting in the Cosmic Cup, they met and clicked with Kumar Pallana, an Indian poet, performer and vaudevillian. Accordingly, he can be found vibing in *Bottle Rocket*, *Rushmore*, *The Royal Tenenbaums* and *The Darjeeling Limited*.

Anderson and Wilson's cinematic fanboy tastes are glimpsed through the actors they chose for small roles during their launchpad era. To wit: Seymour Cassel, a mainstay of the American indie godhead, John Cassavetes, plays Max's working-class father in *Rushmore*, Royal's lackey in *The Royal Tenenbaums* and the ill-fated Esteban in *The Life Aquatic*.

Now that Anderson is established, with a glut of famous actors in his Rolodex, he will ask a known quantity to appear in a new film briefly. There is always a quality to the small roles, there is always space for the actor to act. This is apparent, to the

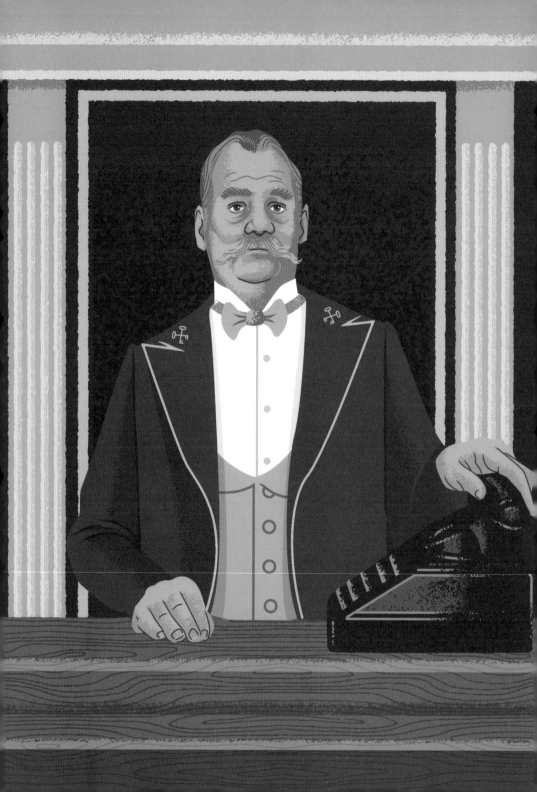

point of parody, in the hotel concierge montage sequence in *The Grand Budapest Hotel*. Bill Murray, Bob Balaban, Fisher Stevens, Wallace Wolodarsky and Waris Ahluwalia, all of whom have worked with Anderson before or would go on to work with him again, have approximately 90 seconds of glory.

CANONERO, MILENA

Italian costume designer Milena Canonero has won four Academy Awards. Her work across five decades includes outfits that still jump out of the screen to entertain and disturb us. Think the white onesie, codpiece and bowler hats worn by the sociopathic "droogs" in Stanley Kubrick's *A Clockwork Orange*. The opposite sensitivity – lace, pastels, corsetry – explodes femininity throughout Sofia Coppola's *Marie Antoinette*, one of the films for which Canonero scooped an Oscar. The other three are Stanley Kubrick's *Barry Lyndon*, Hugh Hudson's *Chariots of Fire* and – let's not forget – Wes Anderson 's *The Grand Budapest Hotel*.

Born in Turin in 1949, Canonero studied art, design history and costume design. Her versatility and work ethic led to directors coming back to the well. She collaborated with Kubrick three times (*The Shining*, plus the two above), and is a mainstay of the Coppolas: father Francis Ford, mother Eleanor and daughter Sofia have used her skillset.

Canonero adopts a studious, detailed galaxy brain approach that makes her an ideal creative mate for Anderson. "It's not the costume itself I like to do, it's more about the meaning I give to the masterpiece," she reportedly once said. Anderson confirmed to *Little White Lies* that, "Milena is especially interested in getting the details of the period right, but she's interested in everything to do with costumes and she's interested in characters and she's interested in, what she calls, 'the complete look' of the movie."

The duo are five films deep into a partnership that runs to: *The Life Aquatic, The Grand Budapest Hotel, The Darjeeling Limited, The French Dispatch* and *Asteroid City.* She is the mind behind the Team Zissou aesthetic – her disciplined approach to primary sources is such that she borrowed the pale blues and reds worn by Anderson's muse, the underwater filmmaker, Jacques Cousteau, as the template for her own designs. Her use of colour is astonishing. Is there a purple to match that of the uniforms worn in *The Grand Budapest Hotel*? "Colours have their own music, and Wes cares a lot that all of them hit the right notes," *The Courtauld* has quoted her as saying. In Anderson she has found a conductor for her own precise touch.

COMEDY

Anderson works in every genre and plunders every emotion, and there is nothing he can't make funny. "I deliver the lines exactly as he says them," said Edward Norton, whose background in method acting could not yield an improvement upon the innate sensitivity of the auteur. There is a certain emphasis to the way that he speaks – that carries over to his characters – which serves to underline the inherent absurdity of all manner of human foibles.

Now the different types of comedy at play are dizzying. From the subtle absurdity baked into a line, to the signature deadpan actor delivery, to the wondrous slapstick of a chase or an escape sequence to the straight-up vulgarity of certain off-colour punchlines. Like the best comedians, Anderson does not use humour to undermine the sincerity of his premises, rather to enrich the mood of the motion pictures, most of which are tragicomic in outlook.

COMMERCIALS

Wes Anderson's commercials illustrate the parallel universe where his critics are right that his films are "style over substance". His adverts for two financial services (AmEx, SoftBank), one high-street fashion label (H&M), one high-fashion label (Prada) and

one lager (Stella Artois) contain all of the visual and tonal elements that make up his signature style. Experiencing the look and the comedy without any emotional gravitas underlines how integral this is to the mysterious moods of his films.

There is one commercial with enough going on in terms of story and character stakes to blur into a short film. *Come Together: A Fashion Picture in Motion* stars Anderson regular, Adrien Brody, as the conductor (Ralph) on a train that is delayed as the 24th December becomes the 25th. The potential human cost of missing Christmas is illustrated by shots of passengers who seem very alone in their separate compartments. There follows an action sequence of the industrious Ralph placing a deadly serious phone call, receiving cargo through the window, and placing a Santa hat on a colleague's head. The pay-off is a genuinely heartwarming festive reveal. This is visual storytelling at its most economical!

COPING WITH THE VERY TROUBLED CHILD

Coping With the Very Troubled Child: Facts, Opinions and Misconceptions by Dr Romulus Trilling, MD, is a book that Suzy from *Moonrise Kingdom* finds at home. Her parents have clearly brought it to try to cope with her. The cover design is a riff on Saul

SEE ALSO:

Anger

Moonrise Kingdom

Neurodivergence

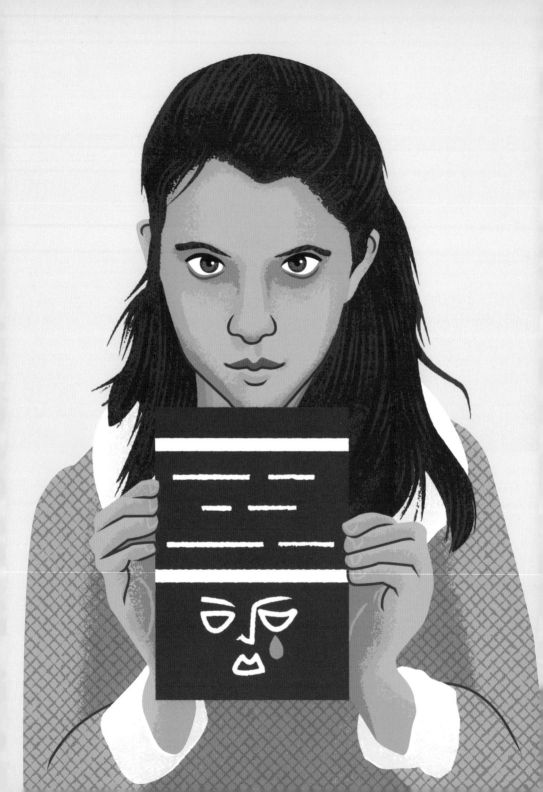

Bass' *Bonjour Tristesse* movie poster, with its crude line drawing of a face blossoming one bright blue tear. The book upset Suzy so much that she brought it with her to run away with Sam.

The book calls out to all the troubled children (present and former) watching, it only deepens our connection that Anderson has said that he found a book like that at home when he was Suzy's age.

COPPOLA, ROMAN

Son of Francis Ford, brother of Sofia and cousin of Jason Schwartzman, Roman Coppola has been one of Wes Anderson's collaborators since he shot second unit on *The Life Aquatic* – the exact point at which distance crept into Anderson's first found film family, the Wilson brothers. Over the subsequent two decades, Coppola has been a creative consigliere, assisting Anderson in bringing his visions out of the woods and onto the screen.

A co-writer on *The Darjeeling Limited*, *Moonrise Kingdom*, *Isle of Dogs*, *The French Dispatch* and *Asteroid City*, his role is not quite covered by that description. He explained it to *Indiewire* in 2018 like this: "It's like you are driving a car to a place in a dream. You're along for the ride to help find this place in the forest, in the zone. There are a lot of boondoggles and sidetracks when writing, ideas and

SEE ALSO:

Asteroid City

The Darjeeling Limited

Family

The French Dispatch

Isle of Dogs

Moonrise Kingdom

characters that can't come to total fruition. The art of this is to know what to emphasize and what not. The notion is to have familiarity with something in a mysterious way and find it again. Clues point to it. My role is as a helper, to sniff out where we are trying to go."

He is a prolific music video director and the list of artists he's worked with is no surprise considering the glamour and magnetism of the family name. They span iconic pop stars (Paul McCartney, Kylie, Mariah Carey), 00s indie bands (The Strokes, Phoenix) and enduring electronic acts (Daft Punk, Sébastien Tellier).

There are two feature films to his name: *CQ* (2001) a homage to camp 60s movies, which was reasonably well received when it premiered out-of-competition in Cannes. But then came the universally panned Charlie Sheen vehicle, *A Glimpse Inside the Mind of Charles Swan III* (2012). "A film is a terrible thing to waste," wrote Roger Ebert in one of the more restrained reviews. This seemed to round off Coppola's personal directing ambitions, although with sister Sofia, he runs his father's production company American Zoetrope.

Considering Anderson's ongoing interest in family dynamics, it's interesting that, between Roman Coppola and Jason Schwartzman, he is nestled in the bosom of perhaps the most influential Hollywood dynasty of today.

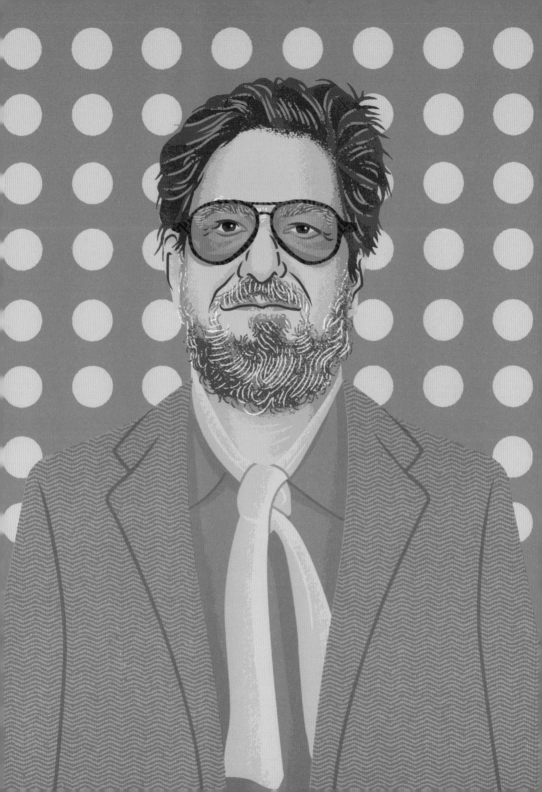

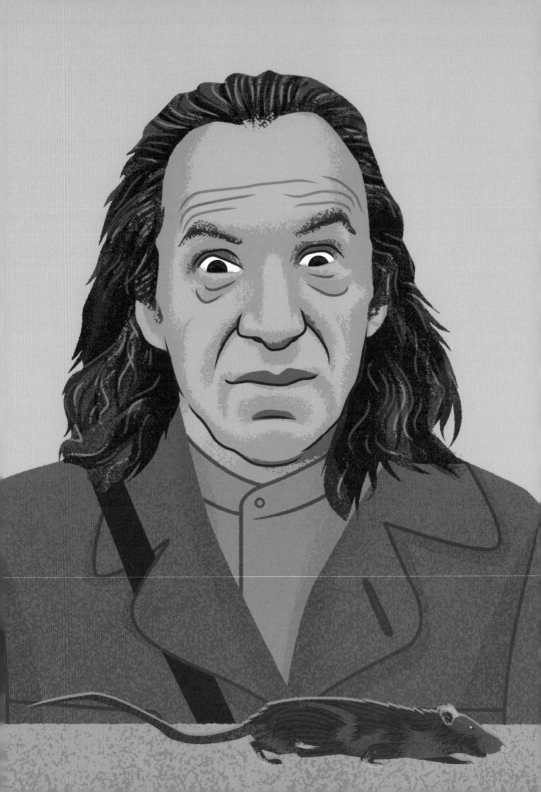

CRUELTY

Anderson does not tend to make films about how society is organized and who lives under the boot of bullying powers. His observations about humanity are loaded onto individual stories. Characters are not symbols for social forces, they are too vividly strange to land as anything but themselves. However, because he focuses so intently on mood, a cruel character can usher in a chill that leaks beyond the frame.

Cruelty is not a quality that defines the characters he writes off his own bat. The same cannot be said about Roald Dahl. Anderson's three adaptations of his short stories released on Netflix with *The Wonderful Story of Henry Sugar*, are cases in point. Particularly one: *The Swan*.

Two sadistic boys find another boy birdwatching. They tie him up and take him captive. This is just the beginning of a *Lord of the Flies*-style descent into savagery. Anderson contrives a mercifully bloodless way to tell the story so that the impunity of bullies and the courage of the victim looms large, rather than grotesque images. By leaning on Rupert Friend as a narrator and using props with imaginative abandon he holds onto a humanity that does not really exist in the original dark little tale. There is equal restraint in the most charged flashpoints of *Poison* and *The Ratcatcher*. Colonial racism and

animal bloodlust flare up and then there is a cut. A veil is drawn over the scenes we don't need to see.

This is a departure from the relishful way he executed, well, executions in *The Grand Budapest Hotel*, where Jopling the assassin sliced off heads and fingers for the camera to find. Perhaps there is something in the Dahl short stories that precludes jaunty comic depiction. Perhaps Anderson is finally reckoning with the worst of us.

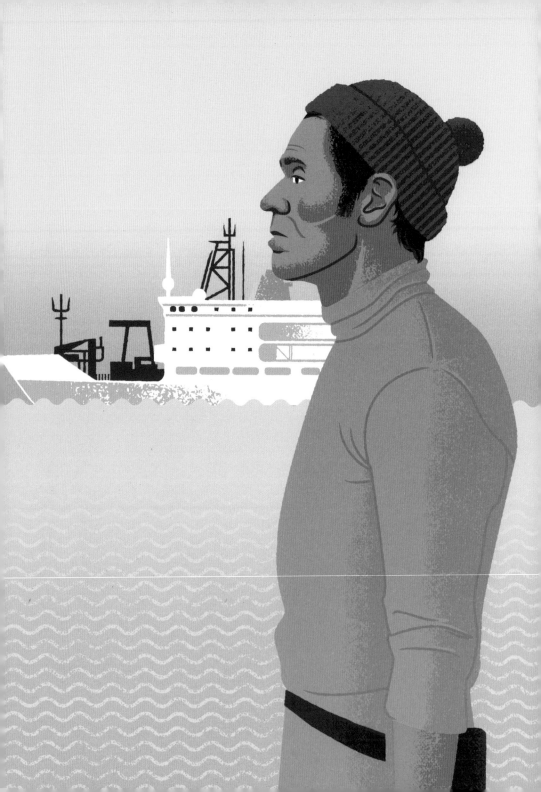

DAFOE, WILLEM

If Willem Dafoe looms larger over Anderson's work than a tally of his time on screen might suggest, that's a tribute to his massive talent. There is no more versatile performer of his – or any – generation. The man can be gnarled, psychopathic, villainous. He can be sweet, sensitive, feminine. He is comfortable in his skin and able to do just about anything with his body: expose it, transform it, use it in unlikely ways to reveal character.

He has gone to physically and psychologically gruelling places for – deep breath – Martin Scorsese, David Lynch, Werner Herzog, Lars von Trier, Robert Eggers, Paul Schrader and Abel Ferrara, and achieved a respectful level of infamy following rumors involving a penis double during the shooting of *Antichrist*. His distinctive face has earned him blockbuster villain roles as The Joker in Tim Burton's *Batman* and the Green Goblin in Sam Raimi's *Spider-Man*.

The last few decades have seen Dafoe relax into an in-demand status that has allowed him to inhabit roles that defy easy categorization and take his warm energy as their start point. Collaborations with Anderson have always had a loose and rangy quality. His meltdowns as Klaus in *The Life Aquatic* inspire great affection among the film's fans, for no one expects a compact little German to be so in

SEE ALSO:

Actors

Asteroid City

The Grand Budapest Hotel

The Life Aquatic

touch with his emotions. Klaus's tearful response to not being picked for the A team is an enduring highlight.

On the flip side, as the leather-clad, fanged assassin Jopling in *The Grand Budapest Hotel* Dafoe appears to be enjoying himself so greatly that it's hard to entirely root against him. One key to understanding his relishful and charged presence is his background in experimental theatre, something he still pursues and got to harness as the excellently named Saltzburg Keitel in *Asteroid City*.

DAHL, ROALD

According to lore, *Fantastic Mr Fox* by Roald Dahl is the first book that Wes Anderson ever owned. His 2009 film adaptation led to an ongoing relationship with the Dahl estate and in 2023 he realized a long-gestating plan to adapt *The Wonderful Story of Henry Sugar*, along with three more shorts from within the same collection: *The Swan*, *The Ratcatcher* and *Poison*.

The stories that bubbled up out of the imagination of the Norwegian-British author Roald Dahl (1916–1990) are beyond comparison. Most famous for his children's books, in which nothing is too strange or macabre to happen, the likes of *Charlie and the Chocolate Factory*, *Matilda* and *The Witches* have such enduring appeal that they are constantly re-imagined and remade.

SEE ALSO:

Brody, Adrien

The Kinks

Sideways tracking shot

Xenophile

With each remake comes a question of how to package aspects of the work that veered from fun nastiness to downright bigotry. Still, a furore followed the news in 2023 that Dahl's publisher Puffin was making small changes to his original texts to suit modern sensitivities.

"I understand the motivation for it," said Anderson at the Venice Film Festival where *The Wonderful Story of Henry Sugar* premiered. "But I'm from the school where when the piece of work is done, and we participate in it – the audience participates in it, we know it – and so I think when it's done, it's done. And certainly, somebody who's not an author shouldn't be modifying his books. He's dead!"

For his part, Anderson does not meddle with the language of the books, the films are loyal to a tee. Neither, however, does he ignore the venom in *Poison* to the point that this short in particular marks a progression from his historic tendency to neuter the matter of racism. The four films are realized with a reverence for Dahl's storytelling skills, while subtly shifting the emphasis of his worldview. The vile deeds and words of characters that Dahl was rather too close to, here, are punctuated with pauses that introduce a new and meaningful auteurial distance.

D

THE DARJEELING LIMITED (2007)

In conversation with Anderson after a 2021 screening of *White Noise*, Noah Baumbach reminded his friend of a time when they were both on a bench together in Paris and Anderson recounted seeing a man with a bandage on his head.

This bandaged Parisian became Francis Whitman (Owen Wilson), the eldest of three brothers and the mastermind behind a train trip through India intended to help them to deal with their family issues a year after their father's death. Peter (Adrien Brody) has left behind his heavily pregnant wife. Jack (Jason Schwartzman) is not over a break-up and obsessively checks his ex-girlfriend's messaging service.

Anderson, Schwartzman and Roman Coppola developed the screenplay using method-writing. They caught a train across India and the story arose through this process. Likewise, the film was shot on a real train moving through Jodhpur, in Rajasthan. The Whitman brothers are well rounded, imprinted with the history of their lives. In the dining car they take on roles from childhood. Francis orders for the two younger brothers who protest their autonomy, before agreeing with his decisions.

Their dynamic is powered by ancient slights and stupid fights and, finally, a resignation that they

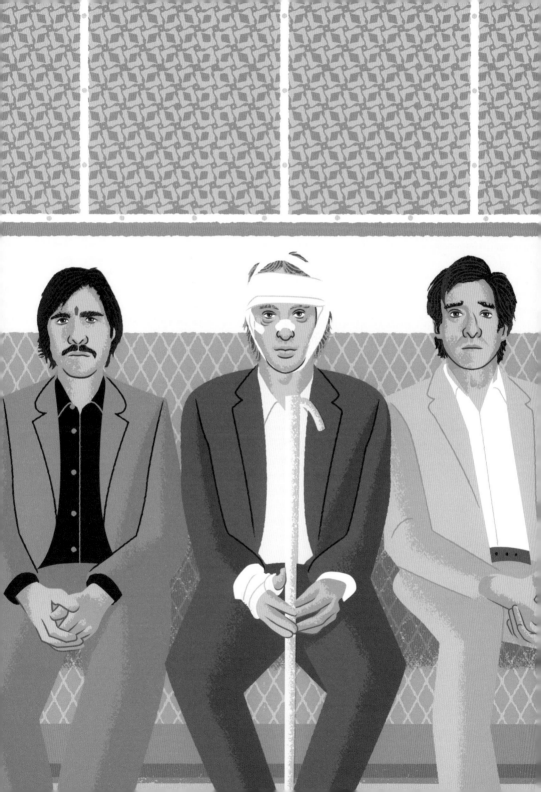

had better hold onto each other. Not only is their dad dead, their mum has absconded to a convent. Wilson, Brody and Schwartzman deliver among their best performances: spiky, layered and full of sadness.

The film premiered at the Venice Film Festival in 2007 preceded by *Hotel Chevalier,* a short film showing Jack's final meeting with his ex-girlfriend. In among the generally positive reviews, criticisms emerged along the lines of cultural insensitivity. Anderson had taken pains in details – Indian typography expert Chandan Mahimkar said the authenticity is such that he's sure an Indian design consultant was hired – however, the story cannot help but belong to a Western tradition of exoticizing a former colonial land while using it as a backdrop.

Even so, the nucleus of the story – the brothers with their grief and their family baggage – pulls at the heartstrings, The Kinks soundtrack works a treat and there is a sideways tracking shot to end all sideways tracking shots.

DAWSON, JEREMY

The Canadian/American has been learning on the fly since graduating from the School of Visual Arts. His early adoption of Photoshop led to his first big break. A friend he had studied with, Darren Aronofsky, asked if he would make graphics for his debut feature, the psychological horror film

SEE ALSO:

Artifice

Pi (1998). From here he was in demand and Aronofsky brought him to help on visual effects for *Requiem for a Dream* (2000) and then second unit directing on *The Fountain* (2006).

His visual-effects skills attracted Anderson, who asked Dawson to help with the stop-motion animation sequences on *The Life Aquatic*. In 2021, Dawson explained to his alma mater, SVA, the happy accident of what followed. "When we finished, Wes said, 'Now that you know about stop-motion, we're doing this movie next that's going to be all stop-motion, *Fantastic Mr. Fox*, and we're working on post-production for *The Darjeeling Limited*, and maybe you can help with that.' And all of a sudden I was a producer, with no idea of how to be a producer."

Dawson has produced every Anderson title since then, making time to produce *The Whale* for old friend Aronofksy, too. He is tasked with the logistical legwork required to make visionary dreams come true. For example: it was necessary to secure the permission of 137 Spanish farmers who each owned a parcel of the land they wanted to film on for *Asteroid City*. It's worth it.

As he told SVA in the same interview cited above: "The nice thing about working with Wes is that he likes to be fearless and try things. A lot of times in art school or in the industry, you'll see people imitating their predecessors, or 'playing adult'. My feeling is, if you really want to be great,

you don't emulate anyone—you just break the rules and go a little crazy with it."

DESIGN

It's not that Anderson's early dream of becoming an architect failed, he just found a way to combine it with another early dream of becoming an author. Precise dialogue within elaborate worldbuilding is a fair expression of those twin goals.

He has also designed inhabitable real-world spaces; namely a train carriage and a bar. His British Pullman train carriage named Cygnus was all old-world refinement and emerald upholstered seats. Bar Luce in Milan takes inspiration from 50s and 60s classic looks with retro Formica chairs, a pastel design scheme and entertainments such as a jukebox and a pinball machine. Anderson described the latter project as "a childhood fantasy come true".

I asked what he thought about one day opening a Wes Anderson theme park and he told me, "I would be very eager to design some rides."

DESPLAT, ALEXANDRE

Composer Alexandre Desplat is so prolific that it makes you want to lie down in a dark room and wonder what you've done with your life. The Parisian first started to play the piano at age five; by

the age of nine, trumpet and flute were on the list. Now in his sixties, he has won Academy Awards for *The Grand Budapest Hotel* and Guillermo del Toro's *The Shape of Water*.

Scrolling through a list of his 200-plus film scores is like watching a magician pulling an endless scarf out of a hat. Among the blockbusters (Harry Potter), prestige pictures (*The King's Speech*) and rogue successes (*Little Women*) are some of the most poetic and original films of our time (Jonathan Glazer's *Birth* and Terrence Malick's *The Tree of Life*).

He first joined Team Anderson for *Fantastic Mr. Fox*, marking a maturation in the director's approach to scoring. Their partnership begins once filming has wrapped, at which point Desplat offers musical ideas. "It could be 10, 20, 30 motifs or instrumental colours," he told *Screen Daily* in 2022, "and then he picks and chooses and I organize the elements and they become the score."

Desplat has gone on to compose the scores for *Moonrise Kingdom*, *The Grand Budapest Hotel*, *Isle of Dogs*, *The French Dispatch* and *Asteroid City*. What keeps him coming back is the freedom of the playground. In the same interview with *Screen Daily* he said, "There's something very childlike about Wes. It's like when you were a child and your best friend came to your house and you closed the bedroom door to play with all your toys. The fantasy

world of childhood comes back and you can try anything."

These two wildly imaginative men have manifested such things as a puppet-sized orchestra – featuring tiny versions of instruments like mandolins, banjos and a glockenspiel – to suit the stop-motion world of *Fantastic Mr. Fox*. On the other side of the scale, they wanted sonic excitement from the old Hollywood-style caper, *The Grand Budapest Hotel,* so Desplat sourced everything from the zither and the cimbalom to Gregorian Chants and Alpine horns.

There is a story like this behind every Desplat/Anderson film composition. The results are highly specific and sensitive beyond words, lacing the pre-existing mood with an extra something-something. As Anderson's films grow more narratively sprawling, the musical compositions of Alexandre Desplat serve as a container, offering one fluid movement in support of a heightened world.

ESCAPE

"Jiminy Cricket, he flew the coop," says Scout Master Ward (Edward Norton) untacking a map on a tent wall to reveal a large hole (a kid's version of the Rita Hayworth poster in *The Shawshank Redemption*). This is *Moonrise Kingdom* and Ward is referring to twelve-year-old cub scout Sam Shakusky (Jared Gilman) who uses a variety of decoys to buy time for different escapes. (See also: a haunting chicken wire effigy made to resemble a child sleeping in bed.)

Sam keeps running away because the authority figures in charge of him don't understand his needs and they don't understand his interests. Faced with a choice between being in their clutches and taking his chances on the lam, well, there is no choice. Like all Anderson antagonists, freedom is vital, imprisonment unthinkable.

The jailbreak in *The Grand Budapest Hotel* is given a serious amount of time and ingenuity. First, there is the smuggling of digging tools using Mendl's pastries. Soon afterwards comes an escape montage that is comically overlong in terms of the sheer number of stages, and the improbable length of a rope ladder that unfurls, unfurls and...unfurls. *Fantastic Mr. Fox* begins with bars descending on a vulpine duo. *Bottle Rocket* opens with Dignan "breaking" his friend Anthony out of a voluntary

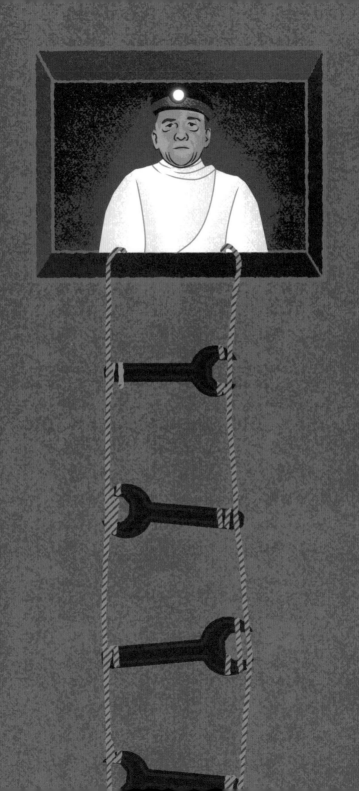

psychiatric facility using tied-together sheets. Anderson taps into the droll sense of camaraderie he feels with characters who pursue the high-stakes DIY theatre of an escape.

Moses Rosenthaler (Benicio del Toro) spends all his screen time in jail in *The French Dispatch*, but that's a little different. He's infatuated with prison guard/art muse, Simone, and sex is the ultimate escape.

EXHIBITIONS

Starting with *Isle of Dogs* and continuing for *The French Dispatch* and *Asteroid City,* props and costumes have found a second life in lovingly laid-out exhibitions in London and New York City. These exhibitions offer a glimpse of the scale of the creative labour behind each enterprise.

Custom-made props, like children's notebooks, that do not have a close-up in a film, have nonetheless been fashioned with an eye for total verisimilitude. We also get to look at the miniatures – cityscape, theatre land, TV studios – and so to understand techniques that evoke cinema before the digital age. The final pit-stop of each exhibition is a real cafe themed to the film – ramen for *Isle of Dogs*, a diner for *Asteroid City* – to really enhance the feeling that we are cosplaying within a Wes Anderson film.

EYE MAKE-UP

The kohl eyes of Margot Tenenbaum (Gwyneth Paltrow) caused a commotion that may never calm down. YouTube and TikTok are full of make-up tutorials instructing devotees on how to achieve the grungy elegance of her aesthetic. Required: poker-straight blonde bob, hair clip, fur coat, cigarette. Optional extras: wooden finger, bathtub, lovestruck stepbrother.

Suzy Bishop (Kara Hayward) caused another wave of "How To Get The Look" articles after the release of *Moonrise Kingdom*. The pink '60s minidress and saddle shoes are capped off by eyes firmly encased in eyeliner and a shock of teal eyeshadow. This style speaks to a lonely twelve-year-old girl's desire to grow up and live like her cultural heroes.

Midge (Scarlett Johansson) in *Asteroid City* plays with the possibilities of stage make-up, riffing on the film's theme of reality and performance sliding backwards and forwards into one another. She turns up at the communal eating area, seemingly with a black eye. Only, it's a shiner she gave herself to prepare for a part, and the black eye is on the inside, anyway.

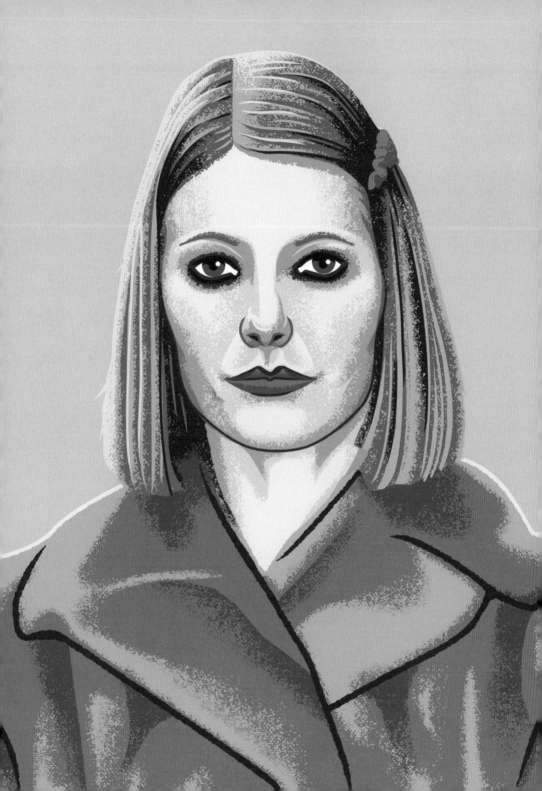

SEE ALSO:

FAMILY

Family is a notion that informs the nature of an Anderson production and is a theme in the finished films. A rapturous gleam appears in the eyes of anyone who has worked with him when asked about the process of making the work. There are no separate trailers, no long drives to set. Actors live together, eat together and breathe the creative project together. Anderson makes himself available to discuss any detail. There are creative activities that make the set feel like a summer camp. On *Asteroid City* there was a tennis tournament, movie nights and a lot of gazpacho.

Anderson is drawn to family members, first it was the Wilson brothers, now it is the Schwartzman/Coppolas. He has employed his own younger brother, Eric – who is an artist – to design props within his films as well as artwork for four Criterion Collection releases.

Children with parents who are either divorced or dead is a motif across *Rushmore*, *The Royal Tenenbaums*, *The Life Aquatic*, *The Darjeeling Limited*, *Moonrise Kingdom*, *The Grand Budapest Hotel*, *Isle of Dogs* and *Asteroid City*. Their vulnerability stemming from loss close to home is what makes these children (and adult children) so moving.

FANTASTIC MR. FOX (2009)

The Fantastic Mr Anderson's first foray into stop-motion animation was based on a novel by one of his storytelling icons, Roald Dahl. The Norwegian/British author, celebrated for his children's stories, had a streak of nastiness that gave his tales a macabre allure, which is irresistible to kids with daredevil imaginations. Eventually, this nastiness would be revealed as stemming from deep within the man himself, when Dahl made his anti-semitism public.

Anderson – for better or for worse – has a gift for cauterizing a story, separating it from troubling connotations, in order to create a vivid and self-contained world. With *Fantastic Mr. Fox*, he dove into a new form of storytelling, going to extraordinary lengths that included visiting Dahl's former Buckinghamshire home, Gipsy House, where he inventoried and then recreated the items decorating Dahl's widow's space, as well as acted out the entire film to serve as a guide to the animators.

This is an adventurous tale of a fox trying to save his family home from the murderous intent of farmers Boggis, Bunce and Bean. Fox is a debonair and nattily dressed creature, voiced with crackling charisma by George Clooney in a casting coup that marked Anderson's growing appeal to A-list

actors. Indeed, Meryl Streep's presence as the fairly unremarkable Mrs. Fox double-scored this point.

Despite the influx of razzle-dazzle, regular players from the loyal troupe include Jason Schwartzman as Ash (son of Mr. and Mrs. Fox), Bill Murray as Badger and Willem Dafoe as Rat. Capers ensue! Lovingly wrought capers! Realized at 3 Mills Studios (who would pop up again for *Isle of Dogs*) *Fantastic Mr. Fox* treats every new location as an opportunity to push creativity to the next level. For all the navigating tunnels, drugging dogs and outwitting farmers at play, the film slots neatly into one of Anderson's signature themes. The community we find through family and other animals is what the struggle for survival is about.

FASHION

As is to be expected from a director who has been on a path to refine his aesthetic, fashion played its part, both on and off the camera. Behind-the-scenes photos of Anderson from his first few films show an ordinary young guy in glasses with short hair, however, now he has morphed into a vision of old-fashioned elegance, rarely out of a corduroy suit, with a signature shoulder-length bob.

Fashion names are drawn to him, and he has made two adverts for Prada and one for the high-street fashion chain, H&M. The point at which a

striking-yet-DIY approach to costumes morphed into a slicker operation was when legendary costume designer Milena Canonero came aboard for *The Life Aquatic with Steve Zissou*. Then came *The Darjeeling Limited* with a monogrammed luggage set by Marc Jacobs for Louis Vuitton. Now, anything is possible.

FRAMING DEVICES

Bottle Rocket aside, Wes Anderson has always used framing devices to divide his motion pictures into sections and playfully acknowledge the artifice involved in filmmaking.

 Rushmore unfolds over a number of months, with each new month ushered in by a crushed-velvet theatre curtain annotated with, say, "October". For *The Royal Tenenbaums*, the ploy was to present the film as if read from a book (cover-designed by Anderson's younger brother, Eric Chase). Pages from the book episodically fill the screen in tandem with Alec Baldwin's narration of the words in print before us. This dual narration made the story seem, somehow, fated.

 More routinely, Anderson has divided his films into parts and chapters, such as in *The Life Aquatic* and *Isle of Dogs*. Of late, he has become more conceptual in the development of these devices. *The French Dispatch* replicated the format of its

magazine subject, announcing from the beginning that it would contain an obituary, three stories, and an endnote. For *Asteroid City*, the approach was something like a nesting doll, so that the film was presented as a play made by actors remembered in a TV documentary. Anderson had begun to create seams of meaning in between the framing devices themselves.

Arguably this found its end game in *The Wonderful Story of Henry Sugar,* in which the very stage on which the action unfolds assembles and disassembles. The walls of a film-set house are rolled into place as a character moves through it. Anderson is inviting us to take pleasure, not just in the stories he tells, but the creative energy of the enterprise.

THE FRENCH DISPATCH (2021)

Taking inspiration from the newspaper format of his beloved *The New Yorker*, *The French Dispatch* is an anthology film, comprising three features, an obituary and an endnote. Set in the fictional French town, Ennui-sur-Blasé, post World War II, it shows us the final farewell issue, as per the wishes of editor Arthur Howitzer Jr. (Bill Murray) who dies at the outset (it is his obituary).

With him goes a romantic way of doing business with writers, which is to say with indulgent largesse.

SEE ALSO:

He pays expenses if a writer stays at the hotel of a former love affair to channel that mood, and he accommodates dramatic exceptions to the word count. Coming out in 2021 into a world where print journalism is a precarious way to make a living, this idealized view of how it could be (how it once kinda was), is imbued with the wistfulness that it is not so. Although very different in terms of narrative and genre, the dreamy nostalgia of the framing twins it with *The Grand Budapest Hotel*.

The first feature, "The Concrete Masterpiece", told by art critic JKL Berensen (Tilda Swinton) concerns imprisoned wildman (Moses Rosenthaler) who comes to the attention of art dealer Julian Cadazio (Adrien Brody) for his painting "Simone in Cell Block H", an abstract nude painting of his guard and lover. The second, "Revisions to a Manifesto", told by Lucinda Krementz (Frances McDormand) is about student revolutionary leader Zeffirelli (Timothée Chalamet), while the third, "The Private Dining Room of the Police Commissioner", is by world-weary food journalist Roebuck Wright (Jeffrey Wright), whose tale involves police chef Nescaffier and the kidnap of the police commissioner's son.

These are detailed mini-movies told at breakneck speed and rammed with visual flourishes, with as much space afforded to the emotional cadences of the journalist telling the story as the

story itself. This switching of the spotlight onto the storytellers themselves only intensified across the two films that followed: *Asteroid City* and *The Wonderful Story of Henry Sugar*.

Filmed in Angoulême, in the southwest of France, the cast all stayed in the same hotel and were given customized slippers as a gift upon arrival.

THE FRENCH NEW WAVE

One way to parse Wes Anderson's increasing disinterest with conventional narrative cinema is to look to his formative influence. The French New Wave style was born in Paris in the late 1950s as a reaction to big Hollywood films with studio-mandated, over-produced plots. A group of critics from the cinephile magazine *Cahiers du cinéma* created their own set of principles, laying the groundwork for what became known as "auteur theory".

Among these trailblazers were Agnès Varda, Jean-Luc Godard, François Truffaut and Éric Rohmer. This list went on to include Jacques Demy, Jacques Rivette, Alain Resnais, Claude Chabrol and Louis Malle.

Auteurist cinema removes control from the studio and places it in the hands of the director. Early French New Wave (or Nouvelle Vague) films were cheap and innovative, launching new editing

SEE ALSO:

Les Quatre Cents Coups (*The 400 Blows*)

Manboys

Paris

Petty crime

techniques, such as the jump cut, and favouring abstract existential ideas over smooth, digestible stories. They felt modern, uncompromising and were often bleak in social outlook.

This sensibility is apparent in Anderson's cinema from the beginning. His now-signature offbeat tone prioritizes a certain kind of mood over the efficient beats of studio storytelling.

Particularly beloved by Anderson is Truffaut's semi-autobiographical debut, *Les Quatre Cents Coups* (*The 400 Blows*), starring Antoine Doinel as a neglected juvenile who drops out of school and drifts into petty crime. It prompted a young Anderson to realize that movies could be extremely personal and gave him, at least in his work, a sympathy for the way that a lack of social stakes and petty criminality blur into each other.

Louis Malle was another creative godhead, with his influence most explicitly found in *The Royal Tenenbaums*, as Richie Tenenbaum speaks a line lifted wholesale from Malle's film *The Fire Within*: "I'm going to kill myself tomorrow."

For Anderson, as for the proponents of the French New Wave, an auteur's personality and control was expressed as much through cinema techniques and modes of production as through explicable plot and character details. This independent spirit delights his fans, infuriates his detractors, but – more to the point – is here to stay.

FUTURA

Anderson has used a vast range of typefaces, non-diegetically (for credits and chapter headings) and diegetically (for signs, book titles, etc.). Although these have evolved across his different eras, with each one carefully selected to draw out character and theme, he is most famous for his use of Futura, a geometric sans serif font.

Futura was designed in Germany by Paul Renner and released in 1927. Its clean, retro modernist style became associated with Bauhaus and has been latterly used by artists and advertisers alike. Within Anderson's filmography its usage peaked in *The Royal Tenenbaums*. YouTuber Linus Boman calculated that it has more screen time than any of the lead characters.

ABCDEF

GHIJKL

MNOPQ

RSTUV

WXYZ

GADGETS

Wes Anderson loves gadgets and gizmos! They are a gift to tone and rhythm. Characters push a button and remain deadpan as an extraordinary piece of engineering whirrs into place. The gag and the delight are the same thing: wondrousness is normal in his world.

The nature of each gadget furnishes the viewer with information about its owner's story. What does it say about Spots's past in *Isle of Dogs* that he has a military-issue exploding tooth that can be deployed at an enemy?

Anderson bore down on this interest to direct a 2010 commercial for Stella Artois titled, simply, "Gadgets". In it, a woman goes home with a man and is left alone in his futuristic '60s apartment for a minute. She plays with a controller filled with silver nobs, causing two televisions to appear, a small, controlled fire and, finally, a perfect-poured pint of Stella Artois, before flipping over the seats of the sofa she sits on, trapping herself inside his sofa.

GOLDBLUM, JEFF

The funniest and most stressful interview of my life was over a bad phone line with Jeff Goldblum. I spent a good deal of the time shouting while he tried to guess what I was saying, but he made it into

sport. Sample: **YOUR MOVIES. DO YOU LOVE THEM ALL EQUALLY OR DO YOU HAVE SOME THAT MEAN THE MOST TO YOU?** You're talking about friends? **FILMS. MOVIES. PICTURES. MOVING PICTURES.** Say that again? **FILMS. MOVIES.** Meetings? **MOVIES!** Ladies? **MOVIES.** Leedees? **YOU MAKE FILMS!** Say it once more. Spell it loudly into the phone...

Synonymous with the sexy, cool, leather-jacket-wearing Dr Ian Malcolm in *Jurassic Park,* Goldblum's comic timing is kept beat-perfect as he plays jazz in his spare time. The star of *Independence Day* has a son born on 4 July. He came to cinema's attention in David Cronenberg's body horror *The Fly* (1986) as the scientist who ends up splicing himself with a fly to goopy, grotesque ends. Six-foot-four and lean as they come, Goldblum's physicality is a gift to visually minded directors; and, of course, Wes Anderson is most certainly that.

Goldblum was first cast in *The Life Aquatic* as Steve Zissou's nemesis in oceanography and romance. Alistair Hennessey is a suave bastard, everything our fraying anti-hero is not, with pristine facilities that border on the militaristic. A naturally warm screen presence, Goldblum dials that down to lean into the polished inhumanity of the successful capitalist.

He stands out for opposite reasons as Deputy Kovacs in *The Grand Budapest Hotel*, for he is the

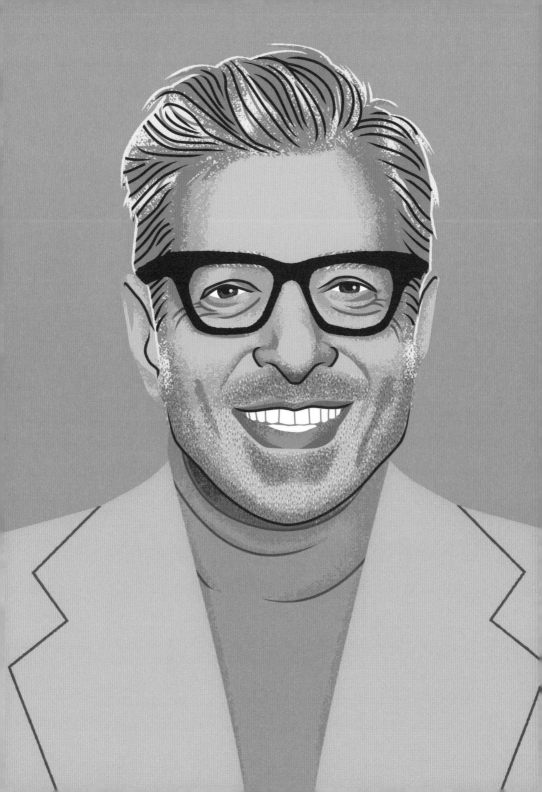

only upstanding man in the nest of vipers that is the Desgoffe-und-Taxis family. The writing is on the wall for Kovacs as soon as his cat is thrown out of a window. He would be reincarnated as a dog, Duke, in the *Isle of Dogs*, and then as a creature from another world in *Asteroid City*. Goldblum learned to walk on stilts specifically for the film. He appears only briefly but it's at such a crucial moment that there were 27 takes for the scene.

THE GRAND BUDAPEST HOTEL (2014)

Wes Anderson's biggest commercial success is indistinguishable from the performance at its centre. Ralph Fiennes is the liberally perfumed, sexually voracious, high priest of hospitality, M. Gustave H, concierge of The Grand Budapest Hotel. This establishment used to attract the richest visitors to the fictional republic of Zubrowka, but is now an enchanting old ruin.

A writer looks back from 1985 to the story he was told in 1965 of the glory days of The Grand Budapest Hotel in 1932. This is how M. Gustave H is teed up – the centre of a double frame of narrators. New lobby boy Zero (Tony Revolori) ends up his ally and protege when Gustave is framed for the murder of a wealthy patron, after she leaves him a priceless painting in her will. The capers

that ensue include murder most horrid, wrongful imprisonment, a daring jailbreak, a secret society, a brave baker, sensational pastries, an assassin, disguises and the rise of facism.

If the breathless plotting sometimes runs rings around the viewer, it is of little consequence. The dynamic between Fiennes and Revolori carries the film, as both actors lean into surprising emotional beats that mean we never have the full measure of their relationship. Meanwhile, Anderson regulars Adrien Brody and Willem Dafoe eat up their baddie roles. Both sport black leather at all times.

Austrian author Stefan Zweig inspired the interwar Mitteleuropean setting and the subplot about The Society of the Crossed Keys is from one of his stories. Of equal influence were old Hollywood movies in which "Europe" is a painted backdrop on a studio lot. Although they shot on locations from Poland to Switzerland, the exterior of the hotel was a miniature, a technique popular in that era but now out of vogue.

Nostalgia saturates nearly every frame, in the depiction of what time has done to the hotel, and in the values of M. Gustave. The story is a nesting doll of appreciation to a man in thrall to a bygone era. As Zero says, "I think his world disappeared a long time before he entered it. But I must say, he certainly sustained the illusion with a marvellous grace."

GRIEF

"Grief makes freaks of us all" is a philosophy that presents itself on examination of how Anderson characters handle and prepare for intimate losses. In *The Darjeeling Limited*, the Whitman brothers reunite a year after their father's funeral for a train trip together across India. Eldest brother Francis has organized the itinerary with a secret caveat that it will end at the nunnery where their mother now lives. The death of the patriarch did not bring the Whitmans together, instead, they scattered to the winds, seeking solace in their own idiosyncratic coping mechanisms.

In *The Royal Tenenbaums*, Royal Tenenbaum (Gene Hackman) tries to pre-emptively mine the love left in his estranged family by pretending to have cancer. For all his skullduggery, he does not make it through the film, yet his antics bring him closer to his most enraged son, Chas (Ben Stiller), who has been driven loopy (he forces his kids to practise fire drills in the middle of the night) by the death of his wife.

Max Fischer is fifteen and a mother down as *Rushmore* opens. He is not, in any way, shape or form, like kids his own age and he romantically pursues his widowed teacher, Miss Cross.

The characters who deal the most smoothly with bereavement are too young to understand

G

the gulf between being and nothingness. Pandora, Andromeda and Cassiopeia, the kid triplets in *Asteroid City*, bury the Tupperware dish containing the mortal remains of their mother with a light-hearted, witchy ceremony. They are so vividly alive that they cannot imagine death.

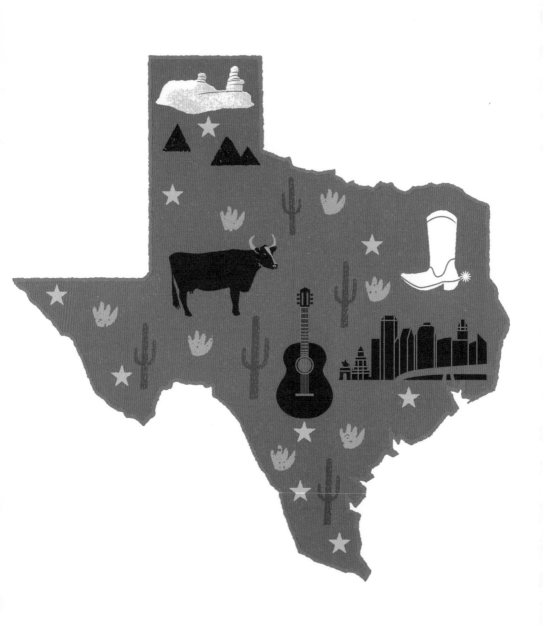

HOUSTON

Wesley Wales Anderson was born in Houston, Texas, on 1 May 1969, the middle child of three boys. His parents divorced when he was eight years old.

These formative experiences can be traced to the divorce at the heart of *The Royal Tenenbaums* and the portrayal of the three Whitman brothers in *The Darjeeling Limited*, but the most Houstonian film of them all is *Rushmore*. Max Fischer's beloved Rushmore Academy was shot at Anderson's real alma mater, St John's School, a prep school west of downtown where, as of 2024, fees are a cool $30,000 a year.

Among imported cast members, Anderson made use of local talent, a practice he would continue across his career. Dr Mark Van Stone did all the calligraphy on behalf of Max, who is the president of Rushmore Calligraphy Club. Van Stone would go on to design the *Pirata Codex*, or Pirate's Code book, for the *Pirates of the Caribbean* films.

SEE ALSO:

The Darjeeling Limited

Family

Paris

The Royal Tenenbaums

Rushmore

HUSTON, ANJELICA

The fiercest matriarchs in Anderson's oeuvre are all played by the formidable Anjelica Huston. In keeping with Anderson's desire to cast actors that channel the cinema of his heroes, she is the daughter of the great American director John

SEE ALSO:

The Darjeeling Limited

The Life Aquatic

The Royal Tenenbaums

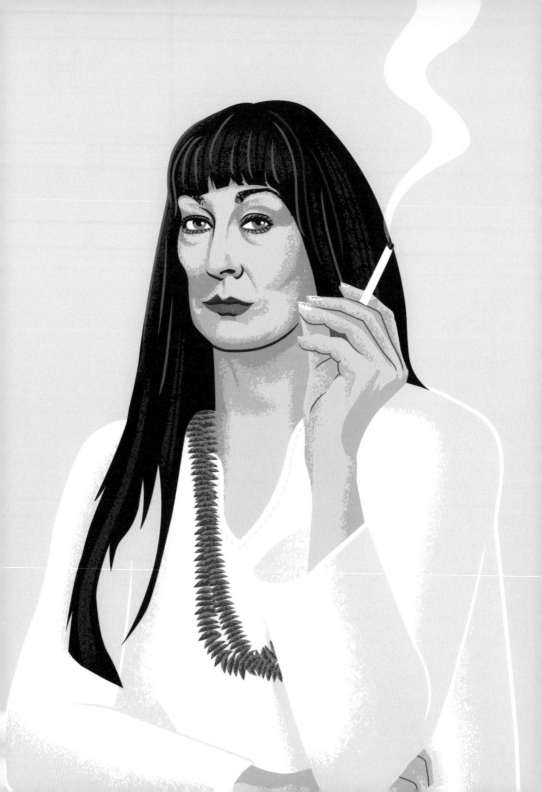

Huston (*Fat City*, *The Misfits*, *The Treasure of the Sierra Madre*). Her mother, Enrica Soma, was a prima ballerina and a model. Anjelica has her mother's grace, her father's grit and an equanimity (and an Oscar) that is all hers.

Across three live-action collaborations with Anderson, her characters' fuses grow shorter. As Etheline Tenenbaum, she is reasonable with roguish ex-husband, Royal, and has a traditional feminine patience (also expressed through a pastel-pink skirt suit) available not just to blood children but to lifelong hanger-on, Eli Cash.

By *The Life Aquatic*, she has become the exasperated Eleanor Zissou, absolutely unwilling to serve as an emotional punch bag for a husband in freefall. Crucially, though, after initially storming off the *Belafonte* she does come back to save the day.

No such luck for the Whitman brothers in *The Darjeeling Limited*, who travel the length of India to find her in a nunnery. She gives as good as she gets after they critique her absentee style of mothering. "Who are you talking to? I don't see myself like that," she says, shrugging off the bonds of parenthood. And – with that – Anjelica Huston seems to have physically departed the Andersonverse.

I

SEE ALSO:

The French New Wave

Old Hollywood

INFLUENCES

The greatest quality that any of us can hope to carry over from childhood is a sponge-like receptivity to new information, inspirations and influences. Anderson is always marinating in some form of culture. His infectious dreaminess might have something to do with always being partially attached to the great cloud that is our cultural hivemind. One way to parse his movies is as remixes of a laundry list of influences. Collaborators are invited to take the same approach. They are sent images, references and titles to seek out. On *The Grand Budapest Hotel* there was a physical movie library of Old Hollywood titles.

Although there are key formative influences – François Truffaut, Louis Malle – each new film represents a new influx of sources. In a way, each new film is an invitation for viewers to rediscover works that may have passed us by. In a way, Anderson (like Martin Scorsese) is as much an advocate for film history as he is a filmmaker. That he successfully combines personal artistic motives with a curator's love of the form is a beautiful thing.

INJURIES

Bandages are rolled out across a filmography full of broken teeth, limbs and hearts. There are crutches,

SEE ALSO:

Cruelty

Grief

Shoot-outs

eye patches, slings and splints. People fall down stairs and are roughed up during fights. Eyes might be red from crying or merely from mace spray. Kids are armed with catapults; adults control robot dogs.

"Which injuries are you apologizing for, specifically?" Walt Bishop asks in *Moonrise Kingdom*. "Specifically? Whichever ones still hurt," replies his wife Laura. They are both lawyers, trying to cauterize, measure and weigh an internal injury as if the right level of apology might offer pain relief.

Body parts are severed. A dog loses an ear in a scrap. A human head is found in a basket. Margot Tenenbaum is missing the tip of her finger. The luckiest characters wear their war wounds with stoicism. The unluckiest succumb to eternal silence.

ISLE OF DOGS (2018)

Wes Anderson's second swing at stop-motion animation was his first based on an original script, co-written with Roman Coppola and Jason Schwartzman. *Isle of Dogs* elides any simple summary. Influenced as much by children's cartoons as by the great Japanese director Akira Kurosawa, the anthropomorphized hounds at the forefront belie an adult tale of political corruption and conspiracy in a near-future Japan.

Mayor Kobayashi exiles all dogs in Megasaki to Trash Island, on the grounds that they have dog flu. In this dog-eat-dog world, bottle mountains stand in for

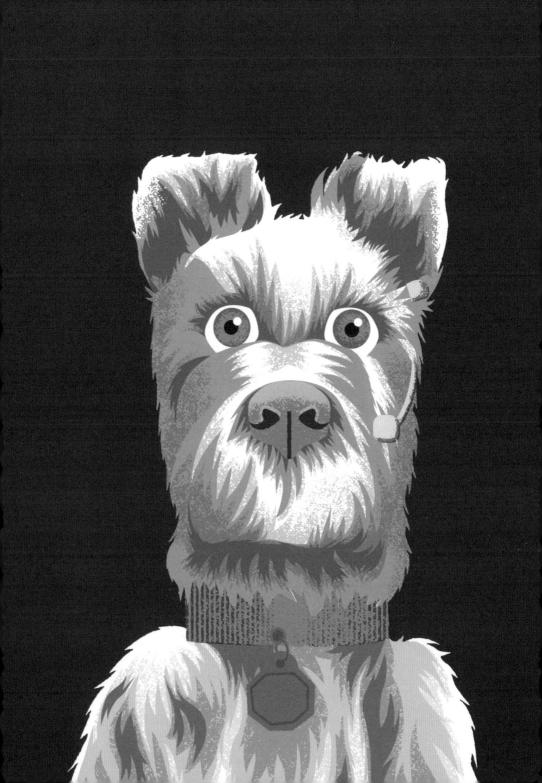

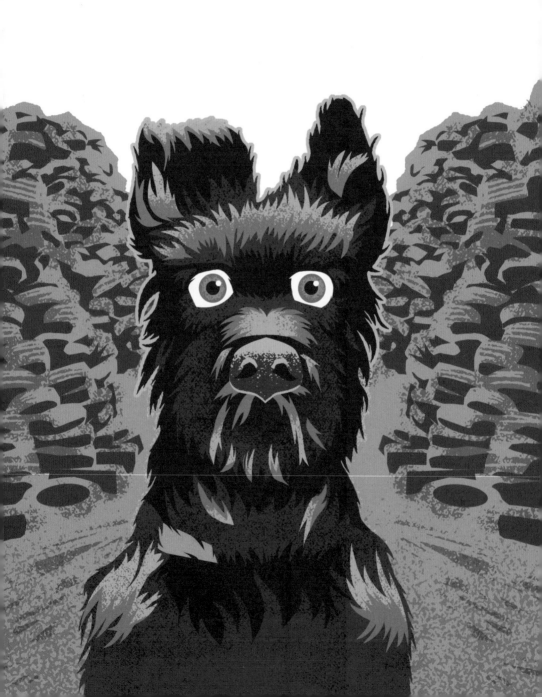

skyscrapers and cannibal dogs are rumoured to roam. The Mayor's orphaned ward, twelve-year-old Atari "The Little Pilot", charts a plane to find his beloved pet, Spots. Five dogs – Chief (Bryan Cranston), Rex (Edward Norton), Boss (Bill Murray), Duke (Jeff Goldblum) and King (Bob Balaban) – are moved to help him, even if Chief does so grudgingly. "I bite," he warns, with the merest hint of longing in his gravelly voice.

Back in Megasaki, foul play is afoot as the Science Party candidate, who had been working on a cure for dog flu, is found dead. It's ruled a suicide, but foreign exchange student Tracy doesn't buy it for a second!

With twists, turns, intrigue and skullduggery to rival paranoid thrillers like *The Manchurian Candidate*, *Isle of Dogs* is equally grown up when it comes to rendering a mood of outsider bleakness. The exiled dogs of Trash Island are no longer soft and easy-going pooches, they are battleworn mutts.

Isle of Dogs opened the 2018 Berlin Film Festival, and it wasn't long before the discourse was full of debates on cultural sensitivity. Anderson's decision to translate the dog's barks into English but not to subtitle Japanese characters came under scrutiny. "All these coy linguistic layers amount to their own form of marginalization, effectively reducing the hapless, unsuspecting people of Megasaki to foreigners in their own city," wrote Justin Chang in his review for the *LA Times*.

J

JAGUAR SHARK

The Jaguar Shark in *The Life Aquatic* gives the film its soul even though it takes a lot in return. Treasured member of Team Zissou, Esteban, is eaten by this shark. The aftermath is caught on camera and the footage included in a documentary that premieres to an unmoved Italian audience. We should say that Esteban is "presumed eaten by the Jaguar Shark", for the film-within-the-film captures the water turning red and Steve Zissou rushing to the surface with the bad news. From then on, revenge is Steve's stated mission. He wants to catch and kill the fish that ate his friend.

The only time we actually see the Jaguar Shark is close to the end, when Team Zissou have crowded into a cramped yellow submarine. The frame is bursting, even by Anderson's standards: Anjelica Huston and Cate Blanchett are up front, a topless, bandaged Jeff Goldblum peers intently from the back. To the strains of Sigur Ros's "Starálfur", they descend past schools of fish, and then – there it is – a glowing stop-motion animation designed by Henry Selick to dwarf the humans. Steve is too moved by its beauty to kill it. Instead of retaliatory violence, he lets go and starts to weep. Every single hand in the submarine reaches out to him. The Jaguar shark is both real and symbolic; both a mighty shining beast and an apocryphal enemy that we respect too much to harm.

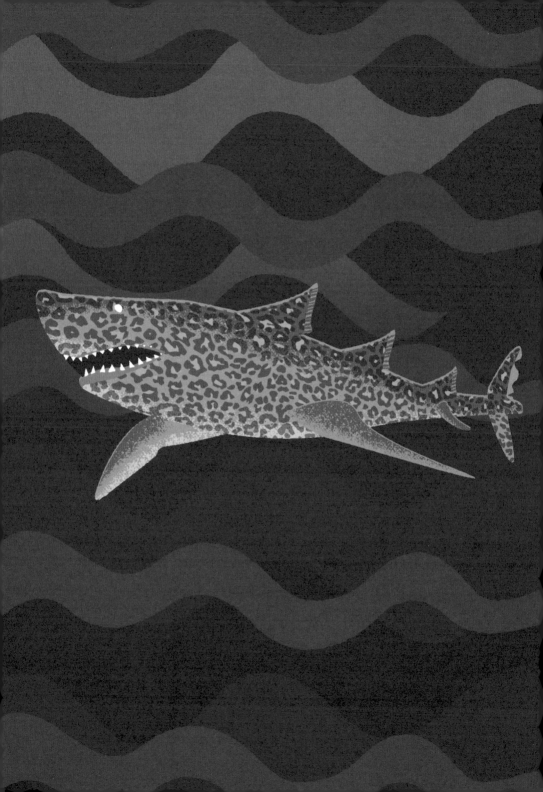

K

THE KINKS

It's hard to pick a stand-out rock 'n' roller from the many beloved by Anderson and his collaborators; The Rolling Stones, The Who, The Beatles, The Clash and David Bowie all feature on his soundtracks. None are *quite* as prominent as the pride of north London – The Kinks. "Nothin' In The World Can Stop Me Worryin' 'bout That Girl" creates the most haunting scene in *Rushmore* and three tracks punctuate *The Darjeeling Limited*, making the band its unofficial composer.

In the opening, after a frantic cab sequence, the thrumming guitar of "This Time Tomorrow" kicks in, lifting up slow-mo Bill Murray and slow-mo Adrien Brody as they run for a train that only the latter will catch. It's a fittingly downbeat way to launch a journey of discovery that stops well short of enlightenment.

The relatively optimistic "Strangers" comes at the film's saddest moment, when the bereaved Whitman brothers attend their second funeral in a year, that of a drowned Indian child. The instrumentalization of this child's death as a way for the repressed brothers to access catharsis has been justly criticized. For the *LA Times*, Swati Pandey wrote that "the film's emotional turning point problematically relies on a tragic event wherein a person of color suffers a tragedy so a person of

whiteness can be fulfilled." Even so, it's hard for the viewer to resist these rich currents of feeling – a testament to the frank power of "Strangers".

With – of course – perfect symmetry, the film closes on another track by The Kinks. "Powerman" propels the Whitman brothers as they run after their train home, hurling aside their father's luggage in order to make it onto The Bengal Lancer. The symbolism here unpacks itself.

LAMINATING MACHINE

Francis Whitman (Owen Wilson) in *The Darjeeling Limited* performs his eldest-child dominance on younger brothers Peter (Adrien Brody) and Jack (Jason Schwartzman) via the production of daily laminated itineraries. His assistant, Brendan (Wally Wolodarsky), is squirrelled away in a separate train compartment with only a laminating machine for company. Brendan is instructed to slide these itineraries under the brothers' door at night. He is not supposed to be seen.

The laminating machine is a source of absurd comedy and character information. Who would transport something so cumbersome across an ocean? Someone eager to maintain authority, someone who uses props with a flourish, someone who enjoys the procedural elements of organization as much as the intended results. It does not feel outrageous to suggest that Anderson has tasked Wilson with sending up his own traits.

When the Whitman brothers are chucked off the train for bringing a poisonous snake aboard, this bulbous laminating machine comes with them.

LETTERS

Letter writing is the fabric of how characters stay in touch and concoct schemes, although they dip

SEE ALSO:

Brody, Adrien

Comedy

The Darjeeling Limited

Gadgets

Schwartzman, Jason

Wilson, Owen

SEE ALSO:

Design

Framing devices

The Life Aquatic

Moonrise Kingdom

Organization

L

into telegrams and phone calls when time is of the essence. Sometimes these letters are handwritten, sometimes they are typed. Always, they are formal, irrespective of the intimacy between sender and sendee. They are vessels for clear information. Sentimentality is not welcome, although a choice deadpan detail is allowed.

The letters that Sam and Suzy send each other in *Moonrise Kingdom* in which they plan to run away is the pinnacle of how correspondence has been incorporated into an Anderson plot. Although their saddest usage is in *The Life Aquatic*. Two characters have become romantically involved and, as life is about to separate them, one hands over a large volume of stamped addressed envelopes so that the other can stay in touch. He then dies before she can use a single one, and she slips the envelopes into his coffin.

THE LIFE AQUATIC WITH STEVE ZISSOU (2004)

"I know I've not been at my best this last decade," admits Steve Zissou (Bill Murray) to wife Eleanor (Anjelica Huston) as she considers leaving him for good. The oceanographer and filmmaker (modelled on Frenchman Jacques Cousteau) is in the midst of a mission to track down the Jaguar Shark that killed his best friend, Esteban. This death was captured

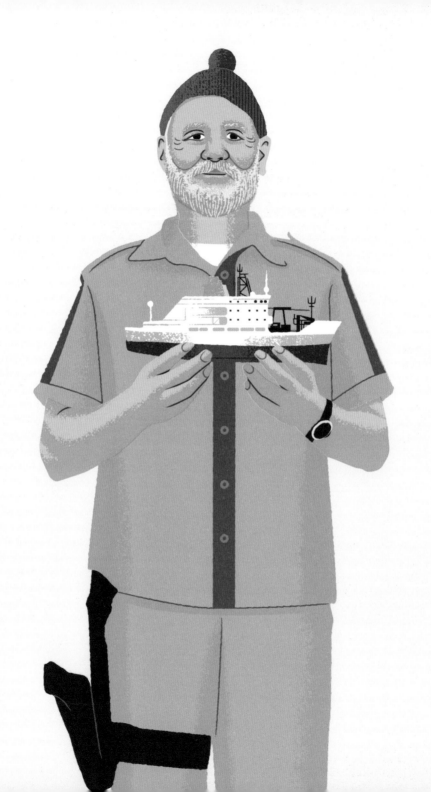

in Zissou's previous film, one that screened to a lukewarm response in Italy.

The only one willing to fund this latest mission is long-lost son and Air Kentucky pilot, Ned (Owen Wilson). This relationship does not cover him in glory, for Steve has neglected Ned until this point, at which it serves him to do so. His ship the *Belafonte* is as down-at-heel as its captain and contains a ragtag crew that includes a pregnant reporter, a Bond company stooge (who is also a human being), a clutch of unpaid interns and two research dolphins. Steve is bullish and erratic, losing the respect of his crew at a faster rate-of-knots than the *Belafonte* can move through the water.

The Life Aquatic did not do well on release with either critics or box-office sales, but it has since been reappraised and developed a cult following. It's a film that marks a fork in the road, as many critics cite it as the film, coming after the much-loved *The Royal Tenenbaums*, at which they began to be alienated by a deadpan style that was settling into place. Whereas for the legions who have stuck with Anderson for the long haul, it was the beginning of a whole new phase of creative exploration.

The obsessive branding of Team Zissou – from the red beanies to the silver-blue wetsuits to the special Adidas trainers – now plays as something of a mission statement for an interest in costuming

L

that would only intensify. This would be the first of an ongoing collaboration with the legendary costume designer Milena Canonero.

Even by his own lachrymose standards, Bill Murray as Steve Zissou is an avatar for depression and his eventual confrontation with the Jaguar Shark that killed Esteban has a moving, existential quality.

LOCOMOTIVES

Planes, trains and automobiles. Submarines, ships and canoes. Scooters, skis and cable cars. Buses, taxis and bikes. Transportation is of crucial importance to Anderson's restless travellers and their need to keep moving. In *Bottle Rocket*, a character absconding with a car (his own, by the way) represents a major setback to the big plan. This at a time when Anderson and Wilson were kicking about in their home state of Texas.

For his fourth film, *The Life Aquatic*, Anderson was no longer interested in staying local, not just to Texas, but to dry land. Most of the action is set aboard the *Belafonte*, and while an existing boat (a British Minesweeper that first set sail in 1958 under the name HMS *Packington*) was used for exterior shots, a to-scale model was built of the interior.

If Anderson has to get a character from A to B (and he often does, because they are generally on the lam) that becomes an opportunity for creativity,

it is not just a problem to be solved with minimal fuss. Such is his desire to innovate that he has been known to break into a new form to up the ante. In the third section of *The French Dispatch*, a police inspector's son is kidnapped and Anderson switches to a cartoon of the event, designed by French animator Gwenn Germain to resemble Tintin comics. Jeffrey Wright's voiceover explains: "the getaway was rendered vividly, if a little fantastically, in a cartoon strip published the following week."

MANBOYS

Tracing a line from Anderson's influences to his output reveals an entrenched preoccupation with wounded masculinity. This is a sensitive seam of screen psychology, a world away from the unreconstructed machismo of, say, Clint Eastwood's films; and it does not preclude the creation of iconic female characters (see Margot Tenenbaum and Suzy Bishop). Even when they are not in the full beam of the spotlight, Anderson's women are sketched with an appreciation of how it feels to deal with Anderson's frequently obnoxious or self-pitying men.

Steve Zissou, by his own estimation "a showboat and a little bit of a prick", is the most aggressive Andersonian man. He is not intended to be a shining paragon of humanity. The premise of the film is to look at a star in decline, a once-successful and beloved filmmaker who is now alienating everyone as he flails about in the midst of grief.

It is not in the characterization of this intentionally flawed man that Anderson tips his hand, but in the nature of the adventures that bring him back to himself. The shoot-out between Team Zissou and the Filipino pirates on a remote island recalls Max Fischer's play in *Rushmore*. Both are deliberately artificial in construction and both have the energy of boys playing men.

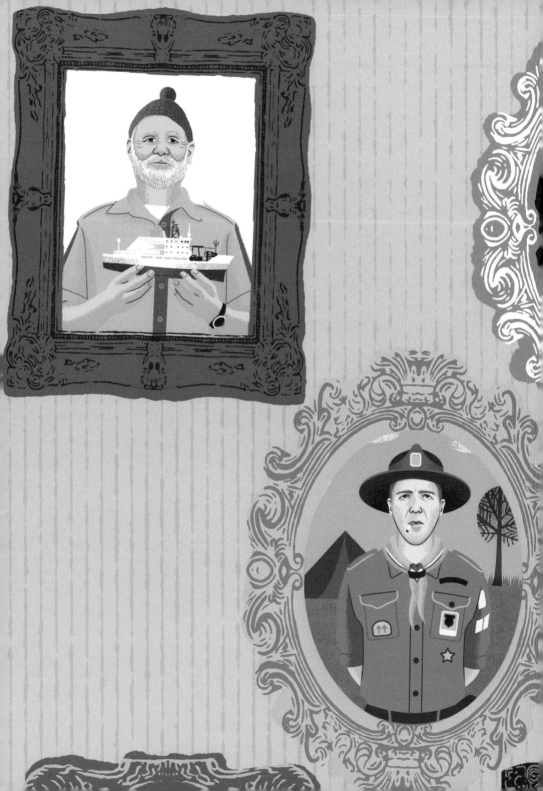

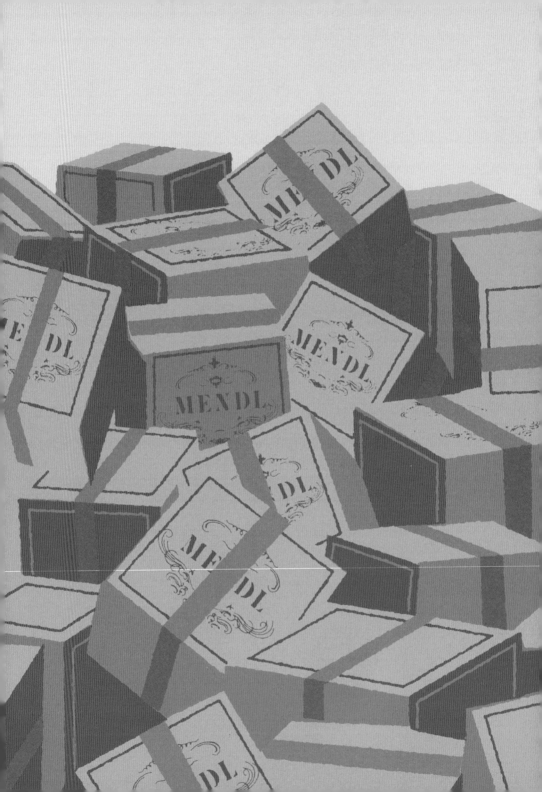

Indeed, the boys dotted across Anderson's work allow for a naked and sincere expression of the pastimes that his adult men don't connect to so easily anymore, to their own detriment. The men of *Moonrise Kingdom* are either depressed (Bill Murray and Bruce Willis) or role-playing in their guise as Scout Leaders (Edward Norton, Jason Schwartzman, Harvey Keitel). There is a sense that growing up, or their best approximation of it, has exacted a heavy tax on Anderson's men, one that not all are willing to pay.

MENDL'S

Mendl's Patisserie, No. 12 Brucknerplatz, Nebelsbad. Pink cake boxes tied with a blue ribbon. Home to such exquisitely crafted pastries that even prison guards refrain from hacking them in half, making them the ideal Trojan horse for jailbreak tools.

If you're lucky you might meet Agatha (Saoirse Ronan) on your visit to Mendl's, although she works in the back, often covered in a cloud of icing sugar. Perhaps, after all, you're more likely to see her cycling through the cobbled streets of Nebelsbad, pink boxes balanced perilously across her handlebars.

Agatha, apprentice to Herr Mendl, love interest of lobby boy Zero, is also "very brave". On several vital occasions, she uses the salivating effect of

holding Mendl's boxes to sneak past gatekeepers, endangering her life in the pursuit of justice as the forces of European fascism close in.

Mendl's is among the biggest break-out stars of any Anderson picture. A little pink van drove around the streets of London to promote *The Grand Budapest Hotel*'s release in 2018. The internet remains awash with recipes for Courtesan au Chocolat (a Mendl's speciality) and fan merchandise riffing on the box and/or the logo. The designer of those boxes, Annie Atkins, admitted that she misspelled "patisserie" on, oh, thousands of the boxes, something that had to be fixed in post-production. "Luckily Wes is a really nice guy as well as a genius," she told *Dazed*.

MOONRISE KINGDOM (2012)

Children are brighter than their adult comrades in the world of Wes Anderson. They have not yet decided to sell out their interests, nor have emotional problems hardened into a paralyzed helplessness. They go after what they want, even – or maybe *especially* – if it is strange.

When orphaned cub scout Sam (Jared Gilman) first meets loner bookworm Suzy (Kara Hayward) while she is dressed as a raven backstage at a church production of *Noye's Fludde*, they strike up a pen-pal relationship that blossoms into a plan to run away.

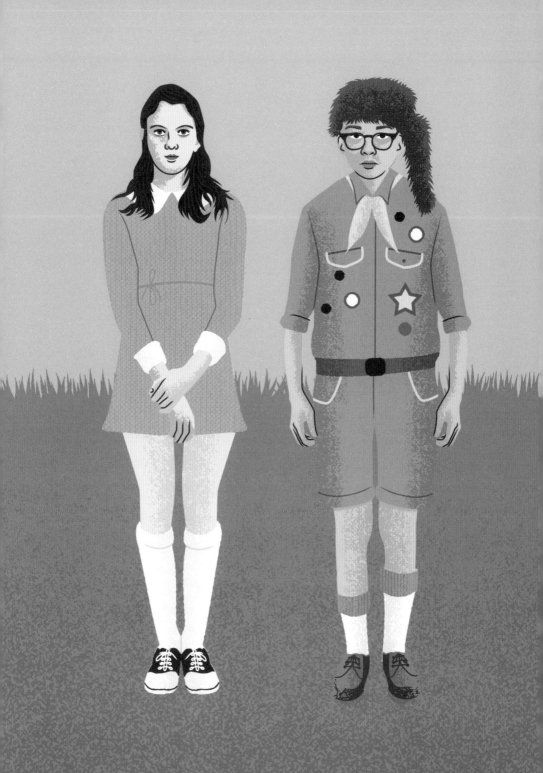

The year is 1965 and we are in New Penzance, New England. This precocious romance has its origin in Anderson's memory of how it felt to have a crush at the age of twelve (the age of the runaways). His film influences range from Waris Hussein's Bee Gees-soundtracked London gem, *Melody* (1971) to François Truffaut's sweet, episodic comedy *Small Change* (1976).

The search for the right Sam and Suzy took eight months. Once Gilman and Hayward were cast there was a preparatory period whereby he learned scouting skills, how to canoe and make a fire, and she practised book reading.

Their escape leads them to an abandoned islet that Suzy eventually christens Moonrise Kingdom. An Alexandre Desplat original score, augmented with a soundtrack taken from Benjamin Britten and a Françoise Hardy needle drop gives their relationship a fantastical quality, as if it is a story in one of Suzy's books.

This contrasts with the deep and squalid unhappiness that the adults are dealing with in New Penzance: an affair, depression and loneliness dogs Mr and Mrs Bishop (Bill Murray, Frances McDormand) and Captain Sharp (Bruce Willis). The orderly world of the khaki scouts offers a more energetic and playful arena, and Edward Norton, Jason Schwartzman and Harvey Keitel have a fine old time playing scout masters.

Now, it is expected that a new Anderson film will premiere at a major film festival, however, when *Moonrise Kingdom* opened the Cannes Film Festival 2012, it was his Cannes debut.

MURRAY, BILL

The deadpan comic actor has been a stalwart of Anderson's ensemble since he was first enlisted for *Rushmore* in 1998. Then 28, the director was relatively unknown, whereas Murray was a household name after the successes of '90s comedies *Ghostbusters* and *Groundhog Day*. Murray was seduced by the quality of the script and went on to offer $25,000 of his own money to pay for a helicopter shot. The rest is history. To date, Murray has held roles – from cameos to leads – in nine of Anderson's eleven features.

The role of Steve Zissou in *The Life Aquatic* was written for him, partially inspired by the explorer Jacques Cousteau, "but there was a lot of Bill in there," Anderson told *Rolling Stone* in 2014. Like all of Murray's meatiest Anderson parts, Zissou is a big, powerful man in the grip of a big, powerful despair. Herman Blume in *Rushmore*, Raleigh St Clair in *The Royal Tenenbaums* and Mr Bishop in *Moonrise Kingdom* are, likewise, prone to catatonic depression. All three alienate their loved ones, see what they're doing and keep on doing it. Murray

commits to strange physical acts, like chopping a tree down in the middle of the night and cannonballing off a diving board. When it's time to deliver dialogue like "I hope the roof flies off, and I get sucked up into space. You'll be better off without me," he brings the world-weariness of a man for whom hope is a foreign concept.

This energy is constant even across bit parts. Anderson cast him in the opening sequence of *The Darjeeling Limited* as an American businessman rushing through busy traffic to catch a train. It looks like his film until, as he runs for the train, he is overtaken by the furiously pumping limbs of Adrien Brody, who becomes the focus. Murray is not seen again until a tracking shot near the end. He is such a familiar presence within the Andersonverse that, to the cognoscenti, his name is shorthand for a brute melancholy.

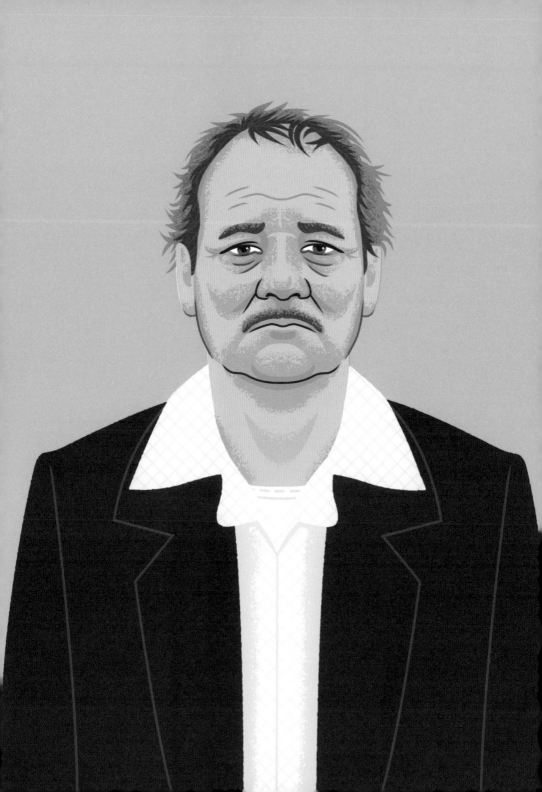

N

NARRATORS

Narrators drop in and out as part of the retinue of resources that Anderson uses to help slice and dice his stories into parts. They introduce chapters, places, dreams and schemes. Sometimes a well-worn voice is there to add a splash of omniscience (Alec Baldwin, Anjelica Huston). In the case of *Moonrise Kingdom*, Bob Balaban donned a pillarbox red coat and green beanie to report on chickchaw migration and inclement weather conditions, more a splash of colour in the film's moodboard than a traditional narrator.

Anderson has not met a formal device that he hasn't tried to switch up, and so it goes for narrators. In *The Grand Budapest Hotel*, the narrator F Murray Abraham wanders into the frame as a link between the hotel's glorious past and its crumbling present. He tells its story to a young writer and, as he talks, we are transported back to this historic timeline where the bulk of the film will unfold.

A narrator becoming part of the narrative, and then switching back again, reaches its *ne plus ultra* in *The Wonderful Story of Henry Sugar*. The key actors play multiple roles. We meet Ralph Fiennes as the author Roald Dahl in his writing shed in Gipsy House. He introduces Henry Sugar (Benedict Cumberbatch), a lazy rich man revitalized by finding in a library *The Story of the Man who can see*

without his Eyes by Dr Chatterjee (Dev Patel). As
one story takes over from the other, the narrator is
handed from Fiennes to Cumberbatch to Patel, and,
for an extra flourish, each actor takes on a new role
in each new story.

NEEDLE DROPS

A needle drop is when an existing song is used
in a movie or a show. Music is used to emotional
effect across Wes Anderson's pictures and there is
a specific sensitivity to his most memorable needle
drops. He favours '60s and '70s rock 'n' roll that is
luxuriously melancholic with a slug of eroticism and
the merest spritz of swagger.

　　There are the depression spells – Bill Murray
in *Rushmore* cannonballing off a diving board
to "There's Nothin' In This World To Stop Me
Worryin' 'Bout That Girl" by The Kinks; Luke
Wilson carrying out a suicide attempt, amid
memories of Margot, to Elliott Smith's "Needle in
the Hay" in *The Royal Tenenbaums*. There is the first
flush of romance as twelve-year-old runaways Sam
and Suzy dance in their underwear to Françoise
Hardy's "Le Temps De L'amour" in *Moonrise
Kingdom* and there is a romance that has run its
course in the short film *Hotel Chevalier*. For the
coda to their break-up, Jason Schwartzman
anticipates the arrival of Natalie Portman by

SEE ALSO:

The Kinks

Moonrise Kingdom

"Needle in the Hay"

The Royal Tenenbaums

Rushmore

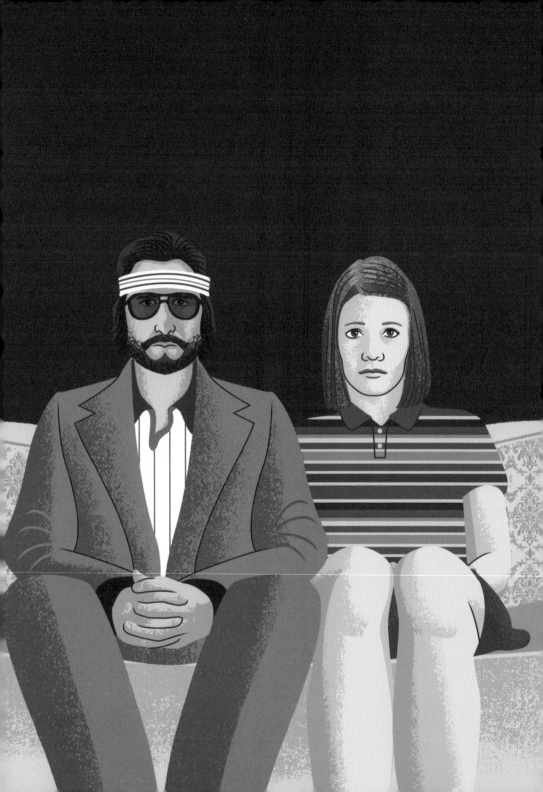

queuing up Peter Sarstedt's "Where Do You Go To My Lovely?"

In these last two instances, the track is a diegetic fact, as a character chooses a song for the scene. Perhaps this is Anderson acknowledging a desire to intentionally set a mood through just the right music choice. Yet, sentiments that rely on the rush of a three-minute pop song possess a desperation. Schwartzman keeps playing the same song because he cannot hold onto the relationship.

"NEEDLE IN THE HAY"

"Needle in the Hay" by the late American singer/songwriter, Elliott Smith, soundtracks the heart of Anderson's filmography. Richie Tenenbaum's suicide attempt in *The Royal Tenenbaums* is so emotional; it's emotional in a way that exists as an undercurrent in all of Anderson's films, only here it breaks the surface like a tidal wave.

Richie can no longer take being in love with his beautiful step-sister, Margot. Quiet misery edges into violent despair after the private detective hired by Margot's husband, Raleigh St Clair, reveals that she is having an affair with their childhood friend, Eli Cash. With Raleigh himself in the foetal position on the sofa, Richie heads into the bathroom to end it all.

As usual, Anderson maximizes the impact of music by editing images to the beat of the song.

SEE ALSO:

Romance

The Royal Tenenbaums

Wilson, Luke

Richie uses a razor to shave before taking it to his wrist. As he acts, he remembers his life, especially Margot. Memories are presented through a montage in which images flicker for a split second as Smith's guitar jabs. A popular interpretation of "Needle in the Hay" is that it's about Smith's heroin addiction. The yearning of addiction is transposed to the yearning of impossible love. We experience life flashing before our eyes and brace for death.

But Richie doesn't die. Smith's lyrics are about being in a desperate state, and in the absence of knowing how to change that state, taking poison just for some peace. The miracle of this song – also present in "Heroin" by The Velvet Underground – is that it makes you *feel* like a heroin addict, it makes you grasp how veins can cry out for brief relief, whether from a needle or a razor.

This explication is in itself a relief. In the narrative context that Richie survives, the "Needle in the Hay" scene holds the vast emotional scope of a character choosing death because he can't imagine living any longer, but the film is bigger than his imagination, and sincerely shows despair as a state he can move through. This interpretation holds for the character of Richie Tenenbaum, although there is no such solace in the tragic end of Elliott Smith.

NEURODIVERGENCE

Cinema's historic representation of neurodivergence is far from storied, notable mainly for autistic people as savants. (Think Dustin Hoffman in *Rain Man*.) Neurodivergence (covering ADHD, autism, OCD, dyslexia, dyspraxia and more) is a term that has slowly taken on momentum, coined by Australian sociologist Judy Singer in the 1990s as a celebratory alternative to clinical diagnosis. As we have become slightly bolder at identifying with our labels, so conversations have mushroomed in subreddits and various corners of the internet about the autism-coded elements of Wes Anderson's universe.

After listening to film journalist Lillian Crawford talking on the *Autism Through Cinema* podcast about how intensely she related to Suzy Bishop in *Moonrise Kingdom*, I was inspired to research and write a longread that sought to map different aspects of my ADHD and autism onto Wes Anderson's cinema. It should be stated with resounding clarity that neurodivergence is not a monolith. An expert, Samantha Hiew, helped to illustrate masking, emotional dysregulation, alexithymia, sensory sensitivity, amygdala hijack and the role art can play in helping us towards mindfulness.

I spoke to Crawford, two members of Anderson's cohort, producer Ben Adler and actor

SEE ALSO:

Adler, Ben

Anger

Moonrise Kingdom

N

Jason Schwartzman. Oh yes, and the man himself. I asked how he felt that this piece was being written. His response:

"How do I feel? You know, the interesting thing is people who identify as neurodivergent often have particular focus in their perception of things, a different way of processing information. I like the idea that there's an audience who is, in a way, paying extra special attention and seeing the movie differently. Possibly seeing the movie more the way I see it, as a filmmaker, and also getting more out of it, a more careful focus. But the main thing is: what does that lead to? I hope and feel that it's creating an emotional experience that's different, because it's an emotional experience that might be inspired by getting more of the details, pulling more of the thing in. I wonder if that makes sense and I wonder if that is true."

The full piece can be found published in two parts on the *Little White Lies* website under the title "The Safe Emotional Spaces of Wes Anderson's Cinema: Part I and Part II".

NORTON, EDWARD

Edward Norton's acting career broke out in the 1990s with dramatic roles in the likes of Gregory Hoblit's *Primal Fear* (1996), Tony Kaye's *American History X* (1998) and David Fincher's *Fight Club* (1999). He played anti-heroes, violent unlikeable

men with a piercing intelligence put to underhand use. Smash cut to the soft-centred comedy stylings of his performances for Wes Anderson. It's surreal to think that Scout Master Ward in his long khaki shorts is played by the same actor who curb-stomped a man to death in *American History X*.

Norton is known for taking a proactive role in the films he joins, and Anderson has vocally credited him as a producer on their first collaboration, *Moonrise Kingdom*. He brings an endearing amount of sincerity to Scout Master Ward, one of two surrogate-father figures to orphaned cub scout, Sam. Ward considers being a scout leader to be his real job (maths teacher on the side). He takes every responsibility very seriously and is rarely out of uniform. He is quietly devastated when, after a series of mishaps, he is asked to hand over his badge.

Inspector Henckels in *The Grand Budapest Hotel* is another uniformed, self-serious professional. Once again, Norton plays with hard and soft, letting officialese melt away as he recognizes M. Gustave H as someone who was "very kind to me when I was a lonely little boy", yet he is too committed to his job to let sentimentality stand in the way of arresting M. Gustave.

Smaller parts in *Isle of Dogs* and *The French Dispatch* followed and then a fabulously juicy one in *Asteroid City*. Schubert Green is a Southern

playwright in the mould of Tennessee Williams, usually clad in the louche writer's uniform of a satin dressing gown. It is from Greene's mind that the story of *Asteroid City* unfurls. He is – to all intents and purposes – the Anderson stand-in and he holds up the world with dandyish pluck, verbal dexterity and an open heart.

NOSTALGIA

As soon as budgets allowed, Anderson travelled with his film productions out of his state – Texas (*The Royal Tenenbaums*) – and out of America (*The Darjeeling Limited*, *Isle of Dogs*), and into the past (*Moonrise Kingdom*, *The Grand Budapest Hotel*, *The French Dispatch*, *Asteroid City*).

"I have some nostalgia for a time that I've never lived in, which is 1965 or 1938 or something like that. I kind of like the old-fashioned world," he told *Esquire* magazine in 2014. This was the year that his most nostalgia-saturated film of all was released, *The Grand Budapest Hotel*.

Anderson's knowledge and techniques have come from studying old masters; his every film arrives with a laundry list of influences in the appendix. Perhaps there is something seductive about the references that become available once you set your movie in the past. Unlike the moving target that is the present, the past (although subject

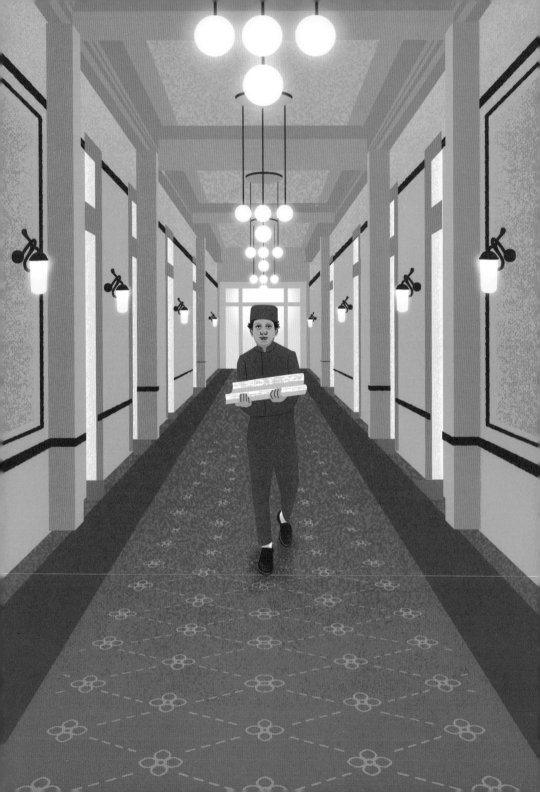

to revisions) has settled into an archive that can be plundered.

It fits his interest in frames-within-frames to burrow a core narrative within a series of narrators that situate a story within a lost era. The effect is a mythological romantic gauze for a protagonist who exists at such a remove that we can only get to them through a relay-race of storytellers. So it is with M. Gustave H and the cast of *Asteroid City*. Although, as early as Steve Zissou in *The Life Aquatic*, Anderson was interested in faded glory and living in a world that no longer sees you as relevant.

NUDITY

The nature of the nudity in Anderson's films divides opinions. Although male characters are technically naked in certain scenes, it is only female nudity that is shown. Fans say this is relaxed in the mode of the European arthouse, critics say it's more like '70s exploitation. So, are we seeing through the gaze of a worldly artiste or a salivating lech? Is there even a meaningful distinction between the two? Even the history of so-called tasteful cinema is the history of the male gaze.

Topless crew member Anne-Marie (Robyn Cohen) in *The Life Aquatic* and Jack's ex-girlfriend (Natalie Portman) who he undresses ahead of their abortive goodbye sex in the short *Hotel Chevalier* are

SEE ALSO:

Animatics

Asteroid City

The French Dispatch

The Life Aquatic

Manboys

worth saluting, before we focus on the full-frontal nudity of two massive movie stars – Léa Seydoux and Scarlett Johansson – in *The French Dispatch* and *Asteroid City.*

Both actresses have said how extremely shy Anderson was when it came down to it. "There was a lot of throat clearing and [Wes] sort of hiding his face," Johansson told *The Decider* of the moment when her character, also an actress, drops her dressing gown to rehearse a scene.

Seydoux's nudity is key to her character and the whole first segment, titled "The Concrete Masterpiece", in *The French Dispatch.* Simone, prison guard, lover and muse of incarcerated artist Moses Rosenthaler is the subject of an abstract painting that propels everything in the story. Anderson omitted this fact in initial discussions with Seydoux, first asking if she wanted a part, then sharing her lines. It was only when he shared with her the animatic that the penny dropped.

As she told *The Belfast Telegraph*: "He makes these little animated films so I watched the film, and it's very funny. He does all the voices. So he played Simone and he did it very well, I have to say. And so I watched the animated film, basically, and that's how I really understood what I was supposed to do."

She told this story with no hint of malice, going on to express accord with the physical

characterization of Simone. "But it's true that she says a lot without speaking. And this is also what I like about Wes, is that you can express a lot with your body language, and it gives a very funny comic dimension."

Seydoux has been publicly working through her feelings on filming nude scenes for a different film, the Palme d'Or winner, *Blue is the Warmest Colour,* for over a decade, telling *Deadline* in 2021 that director Abdellatif Kechiche made her feel "like a prostitute". So it's meaningful that she seems comfortable with her work with Anderson. If there is an anachronistic quality to the way that nudity is used in his work, this might be to do with taking instruction from the past.

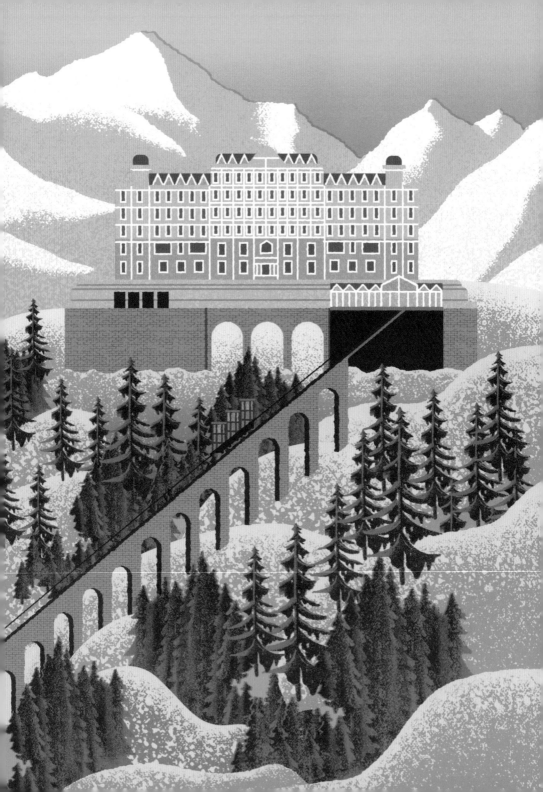

OLD HOLLYWOOD

The greatest comic directors from the golden age of Hollywood, Ernst Lubitsch and Billy Wilder, used blocking as a source of humour. This mode was a carry-over from silent cinema (Lubitsch began in this form in 1914), in which physical set-up needed to convey almost everything, with the dialogue on title cards merely the punctuation between scenes.

Anderson's instinct to make his films *look* funny, rather than relying solely on punchlines and repartee, marks the continuation of a tradition that began over 100 years ago. His most direct homage to Old Hollywood is *The Grand Budapest Hotel* as it unfolds out of a location designed to look more like a Hollywood backlot version of Europe than a real place. He also brought back a classic Hollywood technique, by creating a miniature version of the hotel's exterior.

SEE ALSO:

Comedy

The Grand Budapest Hotel

Organization

ORGANIZATION

The purpose of Anderson's organizational drive is to build a space in which cast and crew have the confidence and structure to experiment creatively. He attracts the best in the business, professionals who are serious enough to find the time to play. As long as they stay within the lines of what is essential to uphold the vision, collaborators have

SEE ALSO:

Actors

Design

Family

Stockhausen, Adam

the chance to draw deeply and sincerely from themselves.

"You've just got to add your personality to it," Maya Hawke told *Little White Lies* about walking onto the *Asteroid City* set. "There's this incredible creativity that's happened before you arrive. And that's an actor's greatest dream – that the people building the canvas on which they get to paint actually care about the canvas."

This is not organization for the sake of being a control freak, this is organization for the sake of being able to let go and let others sing.

PACE

Adrien Brody told the entertainment website *Collider* that Anderson usually has a stop-watch going and will say things like, "Great, we did that in a minute-twenty, let's see if we can do it in 40!" The pace of the dialogue combined with the deadpan stylings is key to the emotional breadth of his characters. It's what creates a tone of tragicomedy. There's no *time* for anyone to wallow, irrespective of how sadly things read on paper. Actors are compelled by force of rhythm not to languish in lines or unleash a great scenery-chewing emotional display. And the way that they march onwards is absurdly funny.

Just as whipping a tablecloth out from under a fully laid table requires one brisk confident whisk, his later films – from *The Grand Budapest Hotel* onwards – unfold at a breathless and breakneck pace. This makes it nigh-on impossible for viewers to take everything in on one sitting. This stepped-up pace has coincided with an intensified focus on deconstructing the form of cinema, and a shift from holding up fictional worlds to showing the moving parts of fictional worldbuilding.

SEE ALSO:

Comedy

Design

PARIS

Somewhere in the life-imitating-art, art-imitating-life cycle is Wes Anderson's relocation to Paris,

SEE ALSO:

The French New Wave

Locomotives

Moonrise Kingdom

P

France. Just as his film settings have travelled from the USA to Europe, so too has the man behind them. It seems as though a stay with Jason Schwartzman in 2006, who was in Paris for *Marie Antoinette*, grabbed him and never let him go.

Moonrise Kingdom was Anderson's last film shot in America. Subsequently he has worked out of France, Spain, Poland, Switzerland and the animation studios of the UK. This sphere suits not just the French New Wave influences that forged his creative outlook, but his lifestyle, for Wes Anderson does not like to fly. Train travel is not just an affectation of his movies, it is a real preference.

PARODIES

Everyone has a Wes Anderson parody in them, including the man himself. His 2006 American Express commercial came years ahead of current social media trends, such as Instagram's "Accidentally Wes Anderson" and TikTok's "You better not be acting like you're in a Wes Anderson film..."

Anderson plays himself for the two-minute commercial subtitled "My Life, My Card". After calling "cut" on a scene starring Jason Schwartzman, he strides through the set, as a sideways tracking shot keeps up, dispensing notes, approvals and his bankcard ("save the receipt"). The distinction

between this parody and the many that have followed is its focus on the process of movie-making. Most today focus on his signature techniques.

While, yes, pastel hues, a doleful figure in the centre of a frame, a montage of images beat-matched to whimsical music, Futura titles specifying a location and an exact time, a fetishistic approach to props and procedures, and whip pans do work to instantly evoke his cinema, the emotional flatness of the results prove that there is a depth to his art that cannot be captured in parodies.

Anderson is doing his level best to block out what is now a viral trend. He told *The Times* in 2023: "If somebody sends me something like that I'll immediately erase it and say, 'Please, sorry, do not send me things of people doing me.' Because I do not want to look at it, thinking, 'Is that what I do? Is that what I mean? I don't want to see too much of someone else thinking about what I try to be because, God knows, I could then start doing it."

PEEPING AND PEERING

Anderson strives to populate every frame with the maximum amount of information in a comic arrangement. He blocks scenes using a visual slapstick that would translate even if the films were on mute. One trope is for characters to appear in a way that is rarely straight. Literally. They are often

SEE ALSO:

Artifice

Comedy

P

introduced, listening, at an angle approaching 45 degrees. They peer around a corner, at the back of the frame, briefly frozen like a meerkat. This is integral to the rhythm and grammar of Anderson's comedy stylings and a way to give necessary entrances a character of their own.

Sometimes, this presents like a private, throwaway joke upstage of the frame when something of greater significance is happening downstage. Once you see it, you can't unsee it. Wes Anderson characters peep and peer, as if their lives depend upon it.

PETTY CRIME

Like his French New Wave forebears, Anderson is drawn to characters inclined to take the law into their own hands, and who are not averse to falling foul of it. A wheeler-dealer mentality is a means for outsiders to muscle their way back into the thrum of life, as opposed to glumly residing on the fringes. Max Fischer does NOT abide by the rules and regulations of The Rushmore Academy when he tries to build an aquarium in the centre of the school baseball field. Although he is not clapped in irons, he is suspended from Rushmore, which, to him, is just as bad.

Royal Tenenbaum may be the biggest huckster to parade his sham goods across an Anderson

picture. The marks are his own family and the hustle is their love, which *almost* makes it forgivable that he pretends to have Stage 4 cancer and has his associate dress up as a doctor to add credibility.

The trials and tribulations of M. Gustave in *The Grand Budapest Hotel* demonstrate that you can end up in jail for abiding by the law if a powerful family wants it that way. He steals the painting he has justly inherited, "Boy With Apple", knowing that he must get ahead of the murderous Desgoffe-und-Taxis family. He is redeemed, as so many people are in Anderson flicks, by a plucky and loyal twelve-year-old (in this case, his Lobby Boy, Zero) through manoeuvres that are not strictly legal, such as a jailbreak.

PHONES

The Andersonverse is a smart-phone-free zone. One allure of the past as a setting is that payphones, rotary phones, field phones and walkie talkies make for more dynamic props than a rectangular sliver of chrome.

Even his early films that are set more-or-less in the present, at a time when mobile phones definitely existed, dodged that brick-shaped bullet. Perhaps his biggest concession to technological advances is the use of an iPod in the short film *Hotel Chevalier*.

Otherwise, this filmography offers a fabulous

SEE ALSO:

Gadgets

Letters

Nostalgia

revival space for the phones of yesterday. In a film world obsessed with communication, the payphone is a particularly useful dramatic device, as it comes with the inbuilt peril of being cut off due to lack of funds, or because you're a student using it during school hours and have been caught, as in *Rushmore*.

On several occasions, Anderson makes use of split-screen in order to show the people on either end of the call. A wonderful example of this is in *Asteroid City* when the junior stargazers break the news of the alien visit to a colleague at their school newspaper, the *Weekly Bobcat*, by calling him at home. Even though it's past usual phone-call hours (Skip's already having his Ovaltine, his mother sharply imparts), the stargazers impress the urgency of their scoop and Skip is summoned to the phone.

POLITICS

People don't think of Anderson as a political filmmaker. His visions are so heightened that it's easy to perceive them as detached from the reality that we occupy. But his films *do* have politics underlying them. His lead characters are regularly forced to reckon with morally dubious authority figures: social services muscle in to try to take Sam away from his young love in *Moonrise Kingdom*, the rise of European fascism ultimately dispatches M. Gustave in *The Grand Budapest Hotel,* and

SEE ALSO:

The Grand Budapest Hotel

Isle of Dogs

Moonrise Kingdom

the corrupt mayor in *Isle of Dogs* is comfortable poisoning a political opponent.

Anderson illustrates these machinations with a postlapsarian grasp of the cruelty of politics and a relish for how establishment antagonists can drive a story. In this respect, his approach to representing politics can be seen as extractive. The death of students during the Chessboard Revolution in *The French Dispatch* is not coloured by any rage against the machine, rather a bitingly tragic romanticism is assigned to fallen heroes.

Anderson has been fairly critiqued for flattening the particulars of the places where he sets his more far-flung films (India, Japan). He uses locations as backdrops, not as guiding stars. Much like his contemporary, Guillermo del Toro, Anderson is a world-builder, conjuring larger-than-life visions that, by design, are not social-realist and should not be judged as such. If there is a lack of follow-through to the political forces at play in his work, this is not to be mistaken for their absence.

PROTÉGÉS

The Andersonverse is a godless world. In the absence of a higher power, the young and impressionable find a false idol among mortal men. These figures tend to tumble from their pedestals before the end of a feature film. Still, mentors and

SEE ALSO:

Manboys

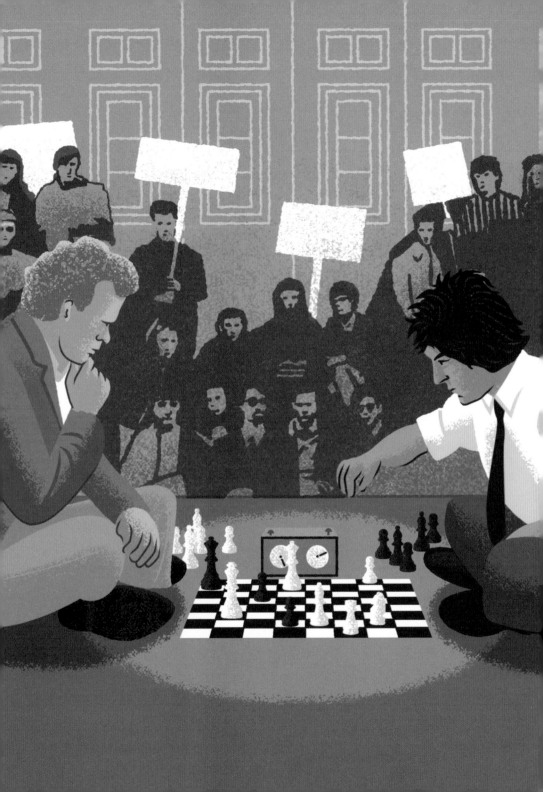

P

protégés crop up all over the shop, hitting both
a visual mark (little and large makes for a strong
silhouette) and an emotive one.

There is Dignan and Mr Henry, Max and Mr
Blume, Raleigh St Clair and his test subject Dudley
and Chas with his mini mes, Ari and Uzi. There is
Steve Zissou and Ned. In the end, there is Captain
Sharp and Sam. There is Zero and M. Gustave. "We
shared a vocation," says the former of the latter, and
this is also true of Arthur Howitzer, Jr. and all the
journalists at *The French Dispatch*. Dr Hickenlooper
trails behind the junior stargazers and space cadets.
She wants to be part of their world. Her flip is no
outlier, for in Wes's works it is usually revealed that
the child is father of the man.

LES QUATRE CENTS COUPS (*THE 400 BLOWS*)

The 400 Blows (1959), the autobiographical debut feature by François Truffaut, was a game-changer for both cinema and a young Wes Anderson. One of the films that gave birth to The French New Wave would, years later, reveal to a teenager in Houston that filmmaking could be extremely personal.

Adolescent Antoine Doinel (Jean-Pierre Léaud) slips through the cracks at home, where he is neglected, and at school, where he is punished. He runs away with the help of a friend and commits petty crimes while drifting across Paris. Explicit parallels can be found in Wes Anderson's adolescent runaway film, *Moonrise Kingdom*, especially in the serious way that the kids look out for each other. *The 400 Blows* is in the DNA of all the child characters across Anderson's filmography. They are never patronized and possess the same dignity and depth as their adult counterparts. Truffaut showed Antoine Doinel growing up across four sequels: *Antoine and Colette*, *Stolen Kisses*, *Bed and Board* and *Love on the Run*.

SEE ALSO:

The French New Wave

Houston

Moonrise Kingdom

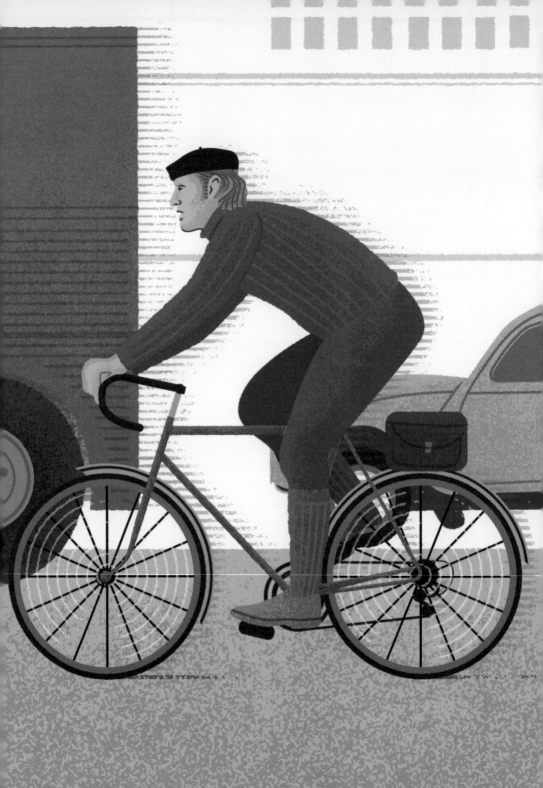

RALES, STEVEN

Very private and very rich are two indisputable facts about one of Anderson's longtime producers. Steven Rales does not give interviews and regularly appears on the Forbes' Rich List, with an estimated net worth of $7.3 billion in 2023.

He has been in business with Anderson since *The Darjeeling Limited* (2007). This was the first film by Rales' production company, Indian Paintbrush, which has gone on to support all of Anderson's subsequent features. A hodge-podge of other American indies fill out its list, from mumblecore Sundance fayre *Jeff Who Lives At Home* (2011) to Park Chan Wook's English-language erotic thriller *Stoker* (2013) to – checks notes – *My Old Ass* (2024).

In 2023, Rales launched Galerie, an online film club with guest curation provided by the great and the good of cinema. Naturally, Anderson was among the first three co-curators, along with actors Ethan Hawke and Maggie Gyllenhaal.

SEE ALSO:

Asteroid City

The Life Aquatic

The French Dispatch

The Royal Tenenbaums

Fantastic Mr. Fox

The Grand Budapest Hotel

Isle of Dogs

The Darjeeling Limited

The Wonderful Story of Henry Sugar

REPORTERS

The French Dispatch is an homage to *The New Yorker*, making it the most naked expression of a love of print media that peppers Wes Anderson's pictures. Whether for a student newspaper or an established title, the profession of "reporter" – with its attendant

SEE ALSO:

Design

The French Dispatch

The Grand Budapest Hotel

Mendl's

tic of relentless note-taking – suits the Andersonian desire to have characters busy attending to and reiterating the details of their worlds.

Many of the characters in *The French Dispatch*, set in the fictional French town of Ennui-sur-Blasé, are drawn from real titans of the trade. The *Dispatch*'s editor Arthur Howitzer Jr. (Bill Murray) is based on *The New Yorker*'s founding editor Harold Ross, its food writer Roebuck Wright (Jeffrey Wright) is an amalgam of James Baldwin, AJ Liebling and Tennessee Williams. And so it goes on.

The presence of reporters in his fictional worlds also affords Anderson the opportunity to create fictional newspapers. News of the death of Madame D in *The Grand Budapest Hotel* is broken by a story in Zubrowka's main newspaper *The Trans-Alpine Yodel*. "Wes also used other newspapers to tell other parts of the story – it was like an entire national press," graphic designer Annie Atkins told *Dazed*. "He wrote the articles, and he wrote some lovely newspaper titles like *Continental Drift* and *The Daily Fact*."

ROMANCE

Anderson locates the giddy excitement of love in the way that characters are framed, rather than in their relationship dynamics. His biggest romance is with cinema itself – its history, its techniques, its heroes and villains. The relationships he writes for

his adults tend to be fraught with disappointment. They tend to contain people adrift, who serve to accidentally sharpen the other's loneliness as opposed to offering a warm communion.

Augie and Midge's conversations in *Asteroid City* are so jaded, so sad. They are literally atomized, performing for each other from opposite cabin windows. His wife has died of cancer, she has two ex-husbands and a history with violent men. He is a photographer, she is a movie star. They sleep together. "This isn't the beginning of something, Augie," she says, the day after the alien visit.

Midge is "a swirl of characters with a lot of Marilyn Monroe", Augie is Stanley Kubrick and the men who came back from World War II with PTSD. They are as much in conversation with yesterday's doomed starlets and traumatized veterans as they are with each other. They are not written to take us fully into themselves, but to reach out across the borders of time and evoke cultural history. To call someone "a romantic" is not always a compliment, for it can mean an inability to grasp reality. What is less real than those who are long gone? The mirage, though, is that dead movie people still alive in our collective memory can *feel more real*.

As a scholar, always marinating in artistic research, Anderson funnels his own gifts as a storyteller into characters composed of people he has known and those who belong to the pantheon

of cinema. This hybrid of influences leads to the creation of characters who seem both mysterious and familiar.

Through close-ups, make-up, lighting, language and so much more, cinema has the capacity to render heroic the private battles that these characters face which those around them cannot compute (for they, too, are subsumed in their own private battles). Anderson uses his skills as a director to dignify characters who are stuck with themselves.

The kids fare better than the adults, the most thriving romances are between Sam and Suzy in *Moonrise Kingdom*, Zero and Agatha in *The Grand Budapest Hotel* and Woodrow and Dinah in *Asteroid City*. To an adult filmmaker, childhood also represents the past, an earnest age to which we cannot return, except through the romantic imagination of cinema.

THE ROYAL TENENBAUMS (2001)

Anderson's third feature, an enduring fan favourite, is set in a version of present-day New York, making it his last film set in a semi-naturalistic vision of his home country for a long time. The screenplay is inspired by JD Salinger's Glass stories (*Franny & Zooey*, etc.) with elements of Anderson's and

co-writer Owen Wilson's childhoods plus a spritz of Orson Welles's family epic *The Magnificent Ambersons* (1942).

The previously genius Tenenbaum children – Chas, Margot and Richie – emotionally crashed and burned when parents Etheline and Royal announced their divorce. Once a brilliant playwright, Margot is now in a loveless marriage with sociologist Raleigh St Clair, whom she is cheating on with childhood neighbour/famous writer, Eli Cash. Richie is floating around at sea. Chas is in a state of paranoia following the death of his wife. This adult brood is driven back under the same roof into their childhood home after Royal announces (falsely) that he is dying of cancer.

The Royal Tenenbaums doffs its cap to its Salinger-esque literary origins by presenting itself as a library book (designed by Wes's bro, Eric) and it is divided into chapters that open with narration from Alec Baldwin.

This was the beginning of Anderson's interest in ensemble casts with screen time divided fairly evenly between Gene Hackman, Anjelica Huston, Ben Stiller, Gwyneth Paltrow, Luke Wilson, Owen Wilson and Bill Murray.

Scenes have a looseness, tightened out of existence in future works, and among them are the most emotionally devastating moments that Anderson has ever created. The taboo love that

Richie feels for his step-sister Margot infuses the film with tragic romanticism. His suicide attempt – in a montage set to Elliott Smith's "Needle in the Hay" – and the FILA-logoed tennis outfit he wears make this Luke Wilson's most unforgettable performance. Gwyneth Paltrow with her fur coat and eyeliner set in motion a fancy dress trend that is still going strong over two decades later.

RUSHMORE (1998)

"I guess you've just gotta find something you love to do and do it for the rest of your life," says fifteen-year-old schoolboy Max Fischer (Jason Schwartzman) to cuckolded tycoon Herman Blume (Bill Murray). Maybe it's too simplistic to put those words in the mouth of then-sophomore director Wes Anderson, but twenty-five years down the line he's on course to doing what he loves (filmmaking) for the rest of his life.

Max's big love is going to his private school, Rushmore Academy, and pretending that his widowed barber father is a doctor. He is a member of almost every club: fencing, theatre, beekeeping, you name it. He is not popular (he has one small blonde friend), and neither is he academically successful. In fact, he is expelled and forced to go to a local comp, much to his heartbreak. He is infatuated with a Rushmore teacher, Miss Cross

(Olivia Williams) and his attempts to seduce her are at once precocious and sincere.

It's hard to imagine anyone other than Schwartzman with his red beret, round spectacles and patrician geekiness as Max. Yet Anderson had initially been looking for a young Mick Jagger-type, full of countercultural anger. A year into the search for Max, Schwartzman auditioned while wearing lime-green New Balance sneakers, and that was that.

Unlike most fifteen-year-olds, Max mostly spends most of his time with adults and ends up in cahoots with Herman Blume. Although things get messy when Herman also falls for Miss Cross. *Rushmore* soft-launched a quality that has become almost a trademark of Anderson pictures: there is no real distinction between the emotional lives of children and adults, and cross-generational bonds are formed accordingly.

Anderson's collaboration with the Wilson brothers continued apace. He and Owen co-wrote the script before filming *Bottle Rocket*, drawing from their own school experiences in Houston, Texas. Wes had written plays since childhood. Owen was ambitious, had been expelled and had a crush on an older woman. Luke plays Dr Peter, an OR nurse and friend of Miss Cross. The dinner scene where Max gets tipsy on whiskey and soda and treats Dr Peter as a love rival is one for the ages.

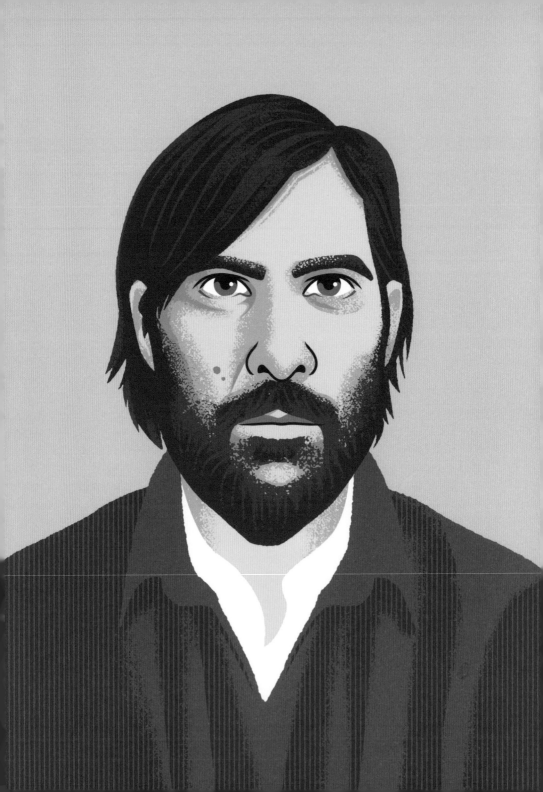

SCHWARTZMAN, JASON

We have watched Jason Schwartzman grow up over the course of his acting collaborations with Anderson. He has gone from a precocious fifteen-year-old schoolboy in *Rushmore* to a widowed father-of-four in *Asteroid City*. He has been a force behind the scenes, co-writing *The Darjeeling Limited*, *Isle of Dogs* and *The French Dispatch*, and has influenced an untraceable number of soundtrack choices. The lifelong friends share a passion for music. Schwartzman has a musical project, Coconut Records, and was briefly the drummer in the band Phantom Planet, whose most famous song, "California", themed '90s teen drama, *The OC*.

His meatiest parts almost bookend Anderson's filmography and he has spoken of the fear involved in playing them – a fear countered by the trust, excitement and intimacy of working with a director who gives himself, outside of set hours, to create a space of endless conversations. "There's no one that I'd rather do that kind of thing with than him," Schwartzman told *Little White Lies*. "We love each other. He's pushing me to go to places that I haven't been before while knowing where I've been."

An in-demand actor across the board (his work ranges from a dystopian showman in the YA franchise *The Hunger Games* to an unravelling party guest in the sketch comedy *I Think You Should*

Leave) there is a distinct flavour to his presence in seven Anderson films. Schwartzman has an inbuilt sense of irony. Pushed to its furthest edge, it can equip him to play an abrasiveness that borders on meanness (see Alex Ross Perry's *Listen Up Philip*), however, when aligned with Anderson's melancomic sensibility, it is touching to behold.

This meanness flickers, like a snake's tongue, in his role of Jack Whitman in both *The Darjeeling Limited* and its companion short film *Hotel Chevalier*. In the latter he broods in a buttercup-yellow Parisian hotel room. His ex-girlfriend (Natalie Portman) whose messages he keeps listening to in *The Darjeeling Limited,* shows up to see him one last time. She says that if they fuck she will feel like shit tomorrow. He says he doesn't care. But he does, and instead of doing that, they look at the view of the city from the balcony.

SHOOT-OUTS

However sophisticated the films become, part of what maintains the slight feeling that Anderson is a twelve-year-old boy cobbling together movies with friends, is the recurrent use of the home-movie staple: the shoot-out. Wherever his characters brush up against danger, there will be one.

Team Zissou vs Filipino Pirates in *The Life Aquatic*, Dmitri Desgoffe-Und-Taxis vs the military

police in *The Grand Budapest Hotel*. Perhaps the purest incarnation of this phenomenon is the altercation that takes place after the khaki scouts track down runaways Sam and Suzy. Weapons include catapults, a bow and arrow and leftie scissors. "If we find him, I'm not going to be the one that forgot to bring a weapon," says one khaki scout, in advance of the combat. In this vision of a child playing an adult, written by an adult playing a child, there is a clue to the origins of Anderson's creative mojo.

SHORT FILMS

Before the recent whammy of Roald Dahl adaptations, Anderson had made shorts, however, most played as bonus material to ease in or out of a feature film. An early exception is calling card, *Bottle Rocket*. It was adapted into the 1996 feature, yet still possesses the unique energy of filmmakers who had no idea what lay ahead of them.

 Co-written with Owen Wilson and shot in black-and-white, the loose 13-minute crime film shot in Dallas has a jazz soundtrack that evokes one of Anderson's French New Wave influences. (The use of Miles Davis in Louis Malle's noirish debut, *Elevator to the Gallows* (1958), is the stuff of legend). As they would in the feature, the Wilson brothers loom large as the amateur criminals planning small-time

SEE ALSO:

Artifice

Bottle Rocket

Cruelty

Dahl, Roald

The Wonderful Story of Henry Sugar

heists – $8 is the profit from one. Robert Musgrave is consistent across both the short and feature as reluctant getaway driver/weed grower, and a lot of the locations – even some of the shots – are the same.

Another striking short is the Jason Schwartzman and Natalie Portman vehicle, *Hotel Chevalier*, a prologue to *The Darjeeling Limited*. Anderson had come to stay with Jason Schwartzman who was in Paris for his role as King Louis XVI in *Marie Antoinette*. The pair lived together and became incredibly close. This led to *Hotel Chevalier*, before they roped in Roman Coppola to join them in dreaming up *The Darjeeling Limited*. *Hotel Chevalier* is a perfect little miniature, a bittersweet post break-up coda, that works with or without the main attraction.

There is a sketch, *Cousin Ben Troop Screening*, that riffs on Schwartzman's character from *Moonrise Kingdom*: and a music video, *Tip-Top Aline*, that complements the second story from *The French Dispatch*.

Which brings us the most considerable short films. *The Wonderful Story of Henry Sugar* was first dropped on Netflix, followed, each a day after the other, by *The Swan*, *The Ratcatcher* and *Poison*. Whether *The Wonderful Story of Henry Sugar* is a short at 39 minutes is a matter of perspective. ("It's not really a movie" is where Anderson landed.) The other three certainly are, each at 17 minutes a pop.

The coherent aesthetic and sensibility across all four, and the use of the same pool of actors, means that watched as a compilation they could almost pass for a modern Wes Anderson feature divided into chapters.

The Swan is the cruellest story that Anderson has ever put to film. It's a tale of bullies, who set out with guns to kill birds, only to take another boy hostage. The violence visited upon the boy contrasts with his resourceful perspective, narrated by Rupert Friend. These clashing sensitivities build to a strange and moving climax straight out of the fairytales of Hans Christian Andersen. *The Ratcatcher* centres around a half-man, half-rodent performance by Ralph Fiennes. His character's rat-catching methods veer into the ghoulish, as Richard Ayoade and Rupert Friend watch on, aghast and agog.

Poison stars Benedict Cumberbatch as a white man in colonial India, frozen stiff in bed as a deadly krait snake has curled up to sleep on his chest. Dev Patel, the narrator, comes home and calls a doctor, Ben Kingsley, to save the day. The extreme tension culminates in a rug pull that points to something more toxic than a snake.

SIBLINGS

Although partial to found families and orphans (Zero in *The Grand Budapest Hotel*, Sam in *Moonrise*

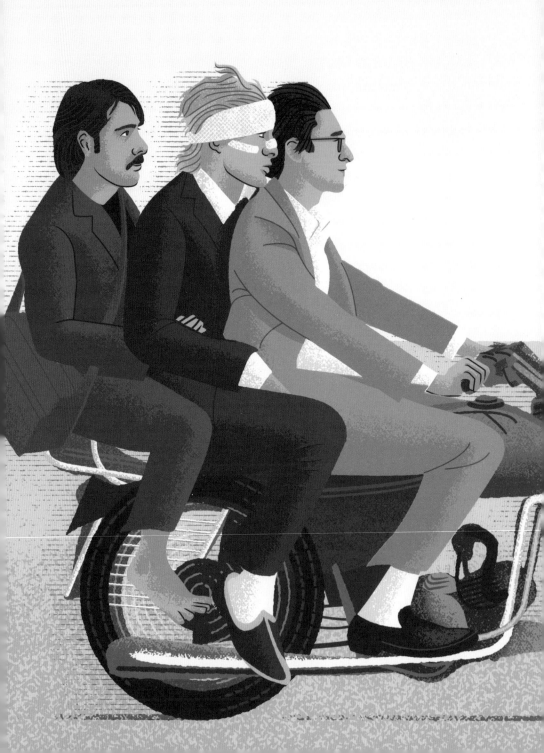

Kingdom), sibling relationships are scattered across the Anderson Cinematic Universe like particularly loud popping candy.

Brotherly bonding forms the arc and core character motives in *The Darjeeling Limited*. Like the Whitmans, Wes has two brothers, Mel and Eric Chase. The latter is an illustrator who has been folded into the film-making process on various occasions. His designs run to the Louis Vuitton luggage in *The Darjeeling Limited* – and eagled-eyed viewers may spot him moseying around in the background of *Rushmore*, *The Royal Tenenbaums*, *The Life Aquatic with Steve Zissou* and *Moonrise Kingdom*.

Other brothers Luke and Owen Wilson piled on their collective acting charisma at the start of Anderson's career, with Owen serving as a writing partner on *Bottle Rocket*, *Rushmore* and *The Royal Tenenbaums*.

Child geniuses turned adult disappointments Chas, Richie and Margot, in *The Royal Tenenbaums* have their sibling dynamic complicated as Margot was adopted. This means that Richie and Margot are legally allowed to be in love with each other, although it is still frowned upon.

SIDEWAYS TRACKING SHOTS

Almost every Anderson film includes a sideways tracking shot. In an era where quick cuts and shot,

187

reverse shot are the standard, expedient grammar for building a film, there is something very classic about a gliding dolly shot, and our knowledge of the labour required to pull it off. A rolling camera, an ever-shifting backdrop, any number of actors coming and going…These are a lot of moving parts to synthesize, especially when the desired result is so precise.

Anderson used this technique to build a sense of mounting absurdity in *Moonrise Kingdom*, as Scout Master Ward walks through Camp Ivanhoe feeding back on the increasingly outlandish projects of his scouts. Its most iconic deployment, though, is at the end of *The Darjeeling Limited*, and incorporates pauses, as the camera glides sideways through individual train carriages, capturing every character in a private preoccupation. To the soundtrack of "Play With Fire" by The Rolling Stones it rolls past every character that could conceivably be on the train, onto ones that simply couldn't, ending on a tiger.

Moments like this illustrate that, although Anderson is a fastidious and technical director, he is extremely interested in emotions and will take flight into magical thinking in order to achieve these strange and ineffable sensations.

STOCKHAUSEN, ADAM

The hawklike focus and saintlike patience of production designer Adam Stockhausen makes

him an invaluable executor of Wes Anderson's visions. Ahead of shooting he works intimately with Anderson and DoP Robert Yeoman to make sure that everything is in place before the actors come to town.

The big-picture questions are: *Where and how do we do this?* For *Asteroid City*, it was a toss-up between shooting at Cinecittà Studios in Rome (as for *The Life Aquatic*) and shooting on location. They ended up building an entire city from the ground in Chinchón, Spain. For every film, Anderson has a ton of very specific references that he shares with collaborators. This time, Stockhausen received old photographs, postcards and movies to inform the overall feeling of the location, like *Bad Day at Black Rock* (1955), *Ace in the Hole* (1951) and movies to inform specific locations: *It Happened One Night* (1934) for the layout of the motel, *Niagara* (1953) for the luncheonette at the cafe.

Another huge question that informs how the vision develops out of the references is: *Is it the exact thing or the feeling of the thing?* Stockhausen joined Team Anderson for *Moonrise Kingdom*, won an Oscar for their second collaboration *The Grand Budapest Hotel* and has been refining his shorthand with the director ever since on *Isle of Dogs*, *The French Dispatch*, *Asteroid City*, *The Wonderful Story of Henry Sugar*, *The Swan*, *The Rat Catcher* and *Poison*. This arc has seen the feel of the thing increasingly

take over from the exact thing. Stockhausen's range is apparent as his work for Steve McQueen (on *12 Years a Slave* and *Widows*) and for Steven Spielberg (on *Bridge of Spies*, *Ready Player One* and *West Side Story*) conjures radically different worlds to the ones of Wes Anderson.

SWINTON, TILDA

Anderson has been smitten with the flame-haired, androgynous British actress since he first saw her in Sally Potter's *Orlando*, it played Sundance in 1993 when he was there with the short *Bottle Rocket*. Almost two decades passed before he snared her for the role of Social Services in *Moonrise Kingdom* and then carried on in this vein for a further four films, casting her as authority figures or someone of integral narrative importance.

Gamely harnessing her chameleonic qualities, Swinton aged up to play Madame D, the elderly lover of M. Gustave (Ralph Fiennes) in *The Grand Budapest Hotel*. Her death, which she predicts, gives rise to capers – art theft, murder most horrid, wrongful imprisonment, jailbreaks and more. Her bit part as a she-pug named Oracle (who may be able to predict the future) in *Isle of Dogs* was more of a token nod to her uncanny powers, yet the stature of her characters has intensified for *The French Dispatch* and *Asteroid City*.

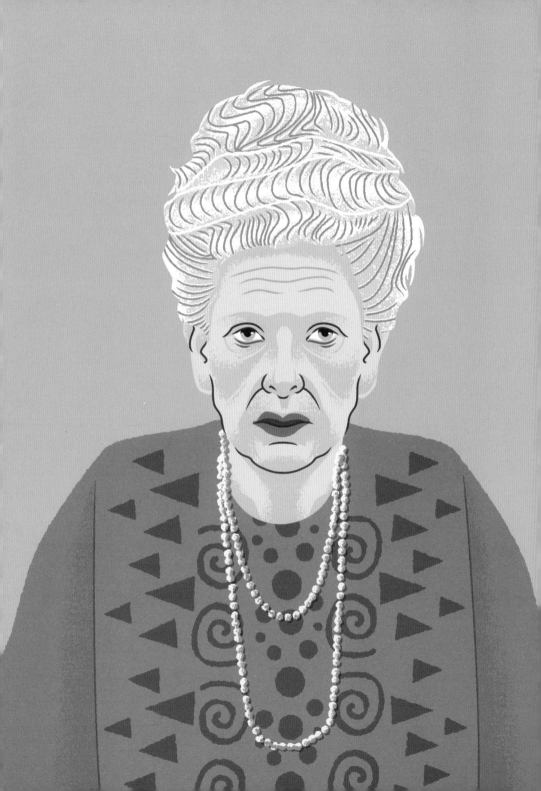

As art critic JKL Berensen, in the first section of *The French Dispatch*, Swinton dons a Yorkshire accent, false teeth and a bright orange dress. She is here to tell the story of wildman artist Moses Rosenthaler (Benicio del Toro) via a slideshow that accidentally includes a tasteful nude of hers truly – a hint of the appetites she enjoys beyond professional writing.

It is as Dr Hickenlooper, the astrologer in *Asteroid City*, where her soulful presence has a chance to come into its own. Swinton is often referred to as a doppelganger of David Bowie, whose alien charisma was at peak in the Nic Roeg film *The Man Who Fell To Earth*, how fitting that here she is a link between this world and the others potentially out there...

Swinton is a prolific actress who has worked with an extraordinary range of boundary-pushing auteurs. Anderson's name is among – deep breath – Derek Jarman, Jim Jarmusch, Joanna Hogg, Apichatpong Weerasethakul, Bong Joon-ho, Sally Potter, Pedro Almodóvar and Lynne Ramsay!

TECHNIQUES

Wes Anderson is among a dwindling band of 35mm purists (co-members include Christopher Nolan, Paul Thomas Anderson and Quentin Tarantino) who are resisting the march of digital filmmaking. Also in his technical toolkit: aspect ratio shifts, use of black and white, chapter headings, signs, binocular shots, sideways tracking shots, whip pans, animation, miniatures, narrators, montages. And – of course – symmetry.

SEE ALSO:

Binoculars

Framing devices

Narrators

Pace

Sideways tracking shots

Whip pans

THEATRE

Theatre was an early creative outlet for the young, pre-*Bottle Rocket* Anderson. He sealed his friendship with Owen Wilson, after meeting him at The University of Texas at Austin, by casting him in his new Sam Shepard-inspired play, *A Night in Tunisia*.

This youthful pursuit was downloaded wholesale onto the character of Max Fischer in *Rushmore*. The film ends with Max's redemption, a Vietnam War-themed play at his new school, Grover Cleveland High School, that is full of adult themes and pyrotechnics.

Margot Tenenbaum is a playwright in *The Royal Tenenbaums* and, once again, her redemption involves putting on a play. For she, like her siblings, achieved extraordinary success as a child only

SEE ALSO:

Asteroid City

Rushmore

T

to burn out for the duration of adulthood until dormant family dysfunctions were addressed and she could write again.

For *Asteroid City*, Anderson drew inspiration from 1950s NYC-based theatre practitioners like Lee Strasberg and the Actors Studio. The film is couched as a play by louche Southern playwright Conrad Earp (Edward Norton essaying Tennessee Williams) and the aesthetic of the actors in seminars is drawn directly from images of that period.

UNIFORMS

Uniforms feature in every single Wes Anderson film. From the yellow jumpsuits Dignan orders to unite his ragtag criminal gang in *Bottle Rocket*, to the ones that blend in as per the *Rushmore* school uniforms, to the show-stealing *The Grand Budapest Hotel* and Team Zissou ensembles, to ones that denote a particular tribe (scouts in *Moonrise*, Pro Dog in *Isle of Dogs*) Anderson has yet to miss a trick.

Uniforms appeal to his desire for order. They are a neat visual shorthand to show a character's bond to a group, as well as a fun opportunity to develop a costume idea that adds to the film's visual identity and a character's sense of style.

Wearing a uniform can be a calculated move to disguise and deceive, or escape and survive. Royal Tenenbaum has his lackey, Seymour Cassel wear a white coat and stethoscope to impersonate a doctor as part of a ploy to convince his family that he is dying of cancer. M. Gustave and Lobby Boy Zero wear monks' robes while trying to track down a missing will.

The most playful touches are the informal uniforms. It's hard to beat the red Adidas tracksuit that Chas wears – with mini-me versions for his sons, Ari and Uzi.

SEE ALSO:

Canonero, Milena

VOICENOTES

Voicenotes are how I bare my soul to my two best friends. I have also received two voicenotes from Wes Anderson – through an intermediary, it should be stressed. I am not the only member of the press corps to have been graced with this intimate provision of answers for publication. Although he still gives in-person interviews to a select few outlets, anecdotal evidence suggests that he has embraced the voicenote as an additional method of communicating with us.

Listening to him answering your questions off-the-cuff is the fastest way to abandon cynicism about his sincerity as an artist. He speaks from the same frequency as his films: detailed, cinephile, playful and casually personal.

His first voicenote was for the *Asteroid City* issue of *Little White Lies*. One of the film's junior stargazers, Woodrow, felt neurodivergent-coded and I spent a long time fashioning a question that didn't seem like a speculative diagnosis, landing on, "to what extent are characters like these intended to recognize neurodiversity?". So, it was very touching when he laughed and threw caution to the wind, "I think that we are talking about something about me..." he said, "There's no intention at all. I feel like what you're probably responding to is some aspect of my own personality. If what you're describing

is accurate, it's probably me relating to people in a way that speaks in a language that we might appreciate together." A massive win for the tribe.

VULGARITY

SEE ALSO:

The Grand Budapest Hotel

Manboys

Although Anderson's literary appreciation is obvious in elegant dialogue that is witty, evocative and hints at oceanic reserves of emotion, he likes to undercut all of this with vulgarity. This serves as a gag of sorts, a rug pulled from under supposedly refined characters and settings.

Romantic rejection elicits crass colours in grown men. Steve Zissou refers to the pregnant reporter who does not reciprocate his crush as "a bulldyke", Royal winds up Etheline's new paramour, calling him "a big Black buck". These lines feel like Anderson having his cake and eating it, critiquing Steve and Royal for their schoolboy pettiness while delighting in subverting civil codes of conduct.

His most cogent combination of high and low language was brewed into the body of one M. Gustave of *The Grand Budapest Hotel*, who is as at home reciting poetry as swearing like a sailor. One motivational speech goes as follows: "You see, there are still faint glimmers of civilization left in this barbaric slaughterhouse that was once known as humanity. Indeed, that's what we provide in our own modest, humble, insignificant...oh, fuck it!"

WHIP PANS

Ninety-degree whip-pans have been in the
Andersonian toolkit from the beginning. The
cinematic equivalent of a double-take serves to
reveal a startling bit of visual information at a pace
that lands like a punchline. Often a character will
look in a certain direction and Robert Yeoman's
camera will follow their gaze with a whoosh. There
is a split-second where the subject of their gaze is
mysterious, however, it is instantly resolved.

In this respect, the whip pan is a very friendly
and sociable piece of grammar. The audience is
never in the dark for long. And because Anderson
fills every new frame with as much information
as possible, once the speeding camera lands on
its 90-degree mark, a flood of pleasurable stimuli
arrives all at once.

SEE ALSO:

Comedy

Pace

Techniques

Yeoman, Robert

WILSON, LUKE

Luke Wilson was in the first three Wes Anderson
films, then their partnership stopped after *The Royal
Tenenbaums*. Nonetheless he will always be famous
for playing one of the most indelible characters in
this whole kit and kaboodle, Richie Tenenbaum.

Oh, the cosmic injustice of being in love with
your beautiful step-sister! This is the fate of former
tennis pro Richie, whose career goes to hell at the

SEE ALSO:

Bottle Rocket

"Needle in the Hay"

Rushmore

The Royal Tenenbaums

match attended by step-sister Margot and her new husband. Richie takes off his shoe, begins to cry and shortly thereafter sets sail upon the open sea, growing a beard and not returning home until his dad pretends to have cancer.

Wilson had shown glimmers of the morose charm that came into their own here, firstly, as Anthony – who is recovering from a nervous breakdown – in *Bottle Rocket* and OR Nurse Peter in *Rushmore,* who is provoked by a self-perceived teenage love rival. But it is through Richie that this mood engulfs the film. The suicide attempt in montage set to Elliott Smith's "Needle in the Hay" is pure uncut emotion – no distance, no deadpan, just despair over a love that never bloomed.

And then that was it. Wilson has acted steadily, recently he had a small (morosely charming) role in Christos Nikou's dystopian romance *Fingernails.* As to what happened to the burgeoning promise of his working relationship with Wes Anderson, it seems to have mirrored the trajectory of the Tenenbaum children: the highest heights came all too soon.

WILSON, OWEN

Beneath the shaggy blond hair, broken nose and lackadaisical voice lies a true cineaste. That Owen Wilson is now best known for broad comedies

SEE ALSO:

Bottle Rocket

The Darjeeling Limited

Family

The Life Aquatic

The Royal Tenenbaums

like *Zoolander* and *You, Me and Dupree* is strange considering his distinctive beginnings.

Working with Wes brings out his most complex flavours. He has acted in eight of the features, with big roles in *Bottle Rocket*, *The Royal Tenenbaums*, *The Life Aquatic* and *The Darjeeling Limited*. However, this description does not do justice to how integral he was in the early days. Their synergy across the first two pictures is so crucial that it's hard to see how *Bottle Rocket* and *Rushmore* could have existed if Wilson hadn't been around.

The pair met in 1989 in a playwriting class at The University of Texas at Austin. "Wes was taken aback by Owen's habit of brazenly reading the newspaper during their intimate nine-student seminar," according to a *Texas Monthly* double portrait. They promptly became friends, creative collaborators and even roommates united by a love of American auteurs like Cassavetes, Peckinpah, Scorsese, Altman, Malick and Houston. An elaborate scheme they cooked up to get even with a negligent landlord set the tone for the amateur crime caper they would write together: *Bottle Rocket*.

Shot in Dallas, *Bottle Rocket* is a real Wilson family affair. Not only does it star Owen and Luke, it features a third brother, Andrew, as a bully whose comeuppance is eventually served by *The Godfather*'s own James Caan. Wilson did not act in *Rushmore*, however, he poured a lot of himself

into the script. Max Fischer is a witches' brew of his and Anderson's school experiences. *The Royal Tenenbaums* is the last film on which the pair collaborated as writers, and it also boasts a plum Wilson performance. As the cowboy-hat wearing, addict writer Eli Cash, his successes are undercut by one irrevocable failure: "I always wanted to be a Tenenbaum."

Poignant losers are something of his stock-in-trade within the Andersonverse, and he cracks open emotions through the clash between an appearance of simplicity and the sadness thrashing around beneath. Both Dignan in *Bottle Rocket* and Francis in *The Darjeeling Limited* attempt to take on leadership roles, preparing elaborate itineraries only to have their charges do their own thing. As Mr Henry says about Dignan: "Poor guy thought he had a team, but he turns out to be a man alone."

THE WONDERFUL STORY OF HENRY SUGAR (2023)

In 2021, Netflix bought the entire catalogue of Roald Dahl stories. Anderson had been in touch with Dahl's widow Lindsay and his grandson Luke for years about adapting *The Wonderful Story of Henry Sugar*, but now he was compelled to work with the streaming behemoth. However, he was, as ever, sanguine, telling *Indiewire*, "because it's a 37-minute movie, it was the

SEE ALSO:

Dahl, Roald

Short films

perfect place to do it because it's not really a movie."

He revealed in the same interview that it had taken a long time to figure out how to adapt the title short story of Dahl's 1977 collection because the specific appeal was: "the writing of it, Dahl's words."

The solution he found to make words the focus was to treat them as the most intact commodity within an otherwise collapsible world. An extremely loyal screenplay lets Dahl's language conduct the visual furniture of cinema in and out of being.

The titular story is nested within the oration of three separate narrators. The centre of the nesting doll is Imdad Khan (Ben Kingsley), an Indian circus performer who learns to see without his eyes. His tale is taken down by Dr Chatterjee (Dev Patel) in a notebook found years later by purposeless playboy Henry Sugar (Benedict Cumberbatch), who teaches himself the same skill in order to win big at casinos. Upon his death, Henry's story is related to the author Roald Dahl (Ralph Fiennes) so it is not forgotten.

With his regular production designer, Adam Stockhausen, Anderson fashions a set that is pushed into place as scenes change, so that walls part and new ones descend as one actor hands over to another. Actors make direct addresses to camera, often without a scene partner, so words upon words come at us.

Richard Ayoade rounds out a troupe of British actors, all of whom play multiple roles. This may not be "really" a movie but it's a heck of a spectacle.

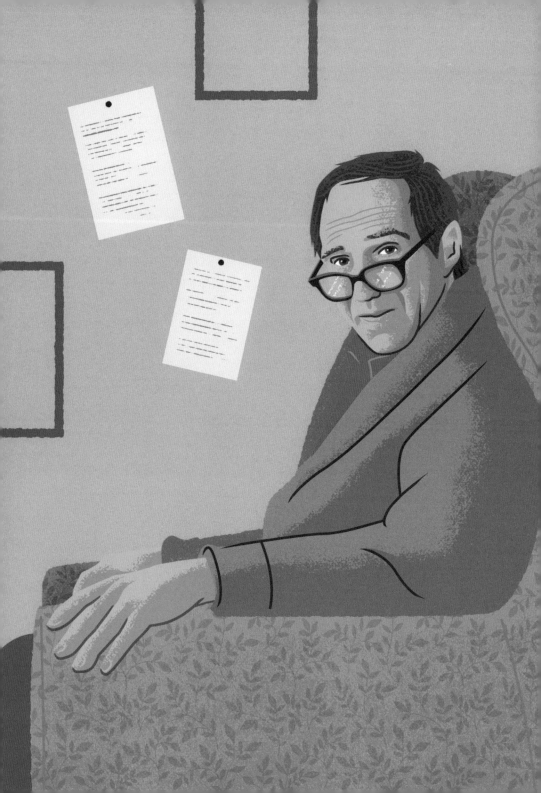

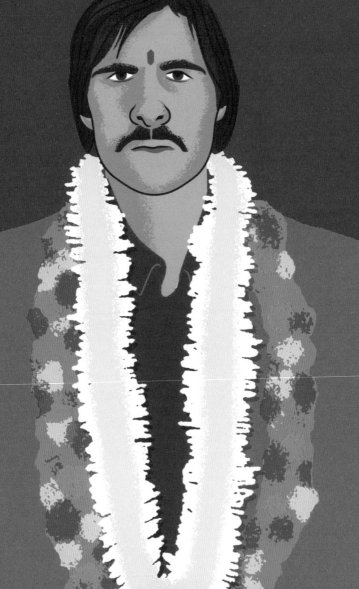

XENOPHILE

SEE ALSO:

The Darjeeling Limited

Isle of Dogs

Politics

"Xenophile", per Merriam Webster dictionary, means: "one attracted to foreign things (such as styles or people)". This definition is both neutral and loaded. It characterizes a positive outlook on "foreign things" that blurs into fetishism and shaves off a dimension or two.

In 2007, Anderson released *The Darjeeling Limited*, in which three American brothers try to heal from the loss of their father over a train journey across India. "*Darjeeling* relies too heavily on setting-as-story, of lands that magically make epiphanies deeper and love affairs more meaningful," wrote Swati Pandey in a piece for the *LA Times* called "White Man's Baggage". His analysis is nuanced and often complimentary. He is alive to the film's self-referential lens as it replicates the perspective of its three self-absorbed Westerners. "The Whitman brothers are the punchlines more often than not," he notes.

So, what's the problem? And, why is it different to use India as an aesthetic backdrop to using a picture-postcard version of France? This false equivalence has the same logic as "all lives matter" in that it razes colonial histories, which is jarring when that history is far from over.

Naturally, it is not on the shoulders of one visionary Texan to right the social injustices of the

world. An artist can bring to life any vision they want, and, likewise, critics are free to scrutinize these visions according to what they possess and what they lack. Anderson's films are many things, but curious about the ongoing blight of racist power structures they are not. His Black and Brown characters are defined by emotional cadences rather than a fully interrogated relationship to whiteness. This is both appealing and stunted.

In his xenophilia, Anderson doesn't *see* racial struggle. As Ellen E Jones writes in her book, *Screen Deep*, Anderson and his contemporary, Sofia Coppola, deal with race by trying to "politely sidestep the topic entirely". The India of *The Darjeeling Limited*, the Japan of *Isle of Dogs* and supporting characters – such as those played by Danny Glover and Kumar Pallana in *The Royal Tenenbaums* – operate in post-racial bubbles that do not land easily in the world of today. There is a discord as white characters, drawn from cinema, life and history, inevitably contain trace elements of supremacy, while their non-white counterparts are not written to have a response to that within their psychological shading.

Y

YEOMAN, ROBERT

All nine of Wes Anderson's live-action feature films were shot by the same cinematographer: one Mr Robert David Yeoman, from Pennsylvania, USA. When not loyally executing Anderson's visions, Yeoman has worked with Paul Feig on *Bridesmaids*, *Ghostbusters* and *Spy*, as well as Drew Barrymore (*Whip It*), Ol Parker (*Mamma Mia: Here We Go Again!*) and Bill Pohlad (*Love & Mercy*).

Yeoman is the only Head of Department to have worked with Anderson since film one, *Bottle Rocket*. "I don't know how he got my address but somehow he did," he told *Little White Lies*, recounting how a polite handwritten letter and the script for *Bottle Rocket* arrived at his home sent by a then-unknown young filmmaker.

It took a few films before Anderson's signature symmetrical style settled into place. Now, the first thing that Yeoman does upon arriving on set is to make sure there is a taped mark dead centre of any space where they will shoot.

Anderson is not interested in shooting coverage, so Yeoman only works with one camera (which he prefers). Although he likes to be open to spontaneity, both men are meticulous planners, walking through locations in advance and planning out where the camera will be. "Whether you execute a game plan or not, show up having one," he told *Creative Spark*.

Yeoman is a fan of soft natural lighting and has taken inspiration from stills photography ever since his parents gave him a Kodak Brownie camera as a kid. He is up for the challenge of working with someone like Anderson, who never wants to execute a visual effect in the standard way. Unlike a lot of cinematographers, Yeoman takes pride in also being the camera operator. Like Wes, he comes alive at the prospect of tending to all the details of his craft.

ZUBROWKA

The fictional Mitteleuropean country of Zubrowka (not to be mistaken with Bison grass vodka) is the location of Wes Anderson's biggest mainstream hit, *The Grand Budapest Hotel*. It boasts a virtuoso performance from Ralph Fiennes, who sets aside the ponderous pacing of Shakespeare to speak at a mile a minute as the exacting and liberally-perfumed concierge, M. Gustave H. His misadventures lead us through a snowy setting with fascism at its fringes, conspiracy at its core and hospitality as its humanity.

The East German town of Görlitz, on the Polish border, was a key location, and while the pink exterior of the hotel is a model, its interiors were shot in the defunct Art Nouveau department store, Kaufhaus Görlitz. Other European locations used were Karlovy Vary, Czech Republic, Dresden, Germany and the Sphinx Laboratory in Alpine Switzerland.

This patchwork of the real and the unreal, and of places knitted together in defiance of geography, serve to give Zubrowka a snow-globe sensibility. Picturesque and contained, familiar and yet out-of-this-world, it is the product of an imagination as rooted in the nostalgic past of literature as anything approximating the present.

SEE ALSO:

The Grand Budapest Hotel

Nostalgia

ABOUT THE AUTHOR

Sophie Monks Kaufman has sought to purge her unwieldy imagination onto
the page since a childhood spent writing stories about princesses eaten by
sharks. Adulthood brought attempts to express the same imagination within
the constraints of a career as a film & culture writer. Sophie has been a film
journalist for over ten years working for British, American and Canadian
publications, from The *Independent* to *IndieWire* to *Hazlitt*. Writing has been
the bassline, while the melody has played out through varied ventures in
filmmaking, film programming and activism. This is Sophie's second book about
Wes Anderson and it is (probably) the most satisfying one.

ACKNOWLEDGEMENTS

Chris Kaufman, the crème de la crème and rock de la rocks of fathers. Filling in the role of mother since 2010 to boot.

Lizzie Stimson, sunny powerhouse and childhood friend who inspired my most concentrated writing sessions.

Pana, a welcome distraction at the end of punishingly cerebral days.

Published in 2025 by Welbeck
An Imprint of HEADLINE PUBLISHING GROUP LIMITED

1

Text © Sophie Monks Kaufman 2025
Illustrations © Nick Taylor 2025
Design and layout © Headline Publishing Group Limited 2025

Cataloguing in Publication Data is available from the British Library

ISBN 9781035419258

Printed in China

MIX
Paper | Supporting
responsible forestry
FSC® C104740

Headline's policy is to use papers that are natural, renewable and recyclable products and made from wood grown in well-managed forests and other controlled sources. The logging and manufacturing processes are expected to conform to the environmental regulations of the country of origin.

HEADLINE PUBLISHING GROUP LIMITED
An Hachette UK Company, Carmelite House
50 Victoria Embankment, London EC4Y 0DZ

The authorised representative in the EEA is Hachette Ireland, 8 Castlecourt Centre, Dublin 15, D15 XTP3, Ireland (email: info@hbgi.ie)

www.headline.co.uk
www.hachette.co.uk